The Frick Collection

Handbook of Paintings

The Frick Collection in association with Scala Publishers 2004

Front cover illustration: Jean-Auguste-Dominique Ingres, Comtesse d'Haussonville

Back cover illustrations (top to bottom): Hans Holbein the Younger, *Sir Thomas More* (detail); Johannes Vermeer, *Mistress and Maid* (detail); Agnolo Bronzino, *Lodovico Capponi* (detail)

This publication is made possible, in part, by Furthermore, the publication program of the J. M. Kaplan Fund, and by the Fellows of The Frick Collection.

©1971, 1978, 1985, 1990, 1994, 2004 by The Frick Collection

All rights reserved

Published by The Frick Collection, New York, in association with Scala Publishers, London Edited by Elaine Koss Design Linda Males MCSD

Library of Congress Catalogue Card Number: 85-80887

ISBN 0-912114-09-6

Preface

This *Handbook of Paintings* is planned primarily for the use of visitors while viewing the pictures in the galleries of The Frick Collection. It is a new edition, substantially revised, of the *Handbook* last published a decade ago. The text was compiled from contributions made by past and present members of the curatorial staff. For more complete information on the paintings, the reader is referred to Volumes I and II of *The Frick Collection: An Illustrated Catalogue*, published in 1968. Photography for the *Handbook* was the work of Richard di Liberto and previous staff photographers. This is the first edition that reproduces all the works in color.

We are grateful to Furthermore, the publication program of the J. M. Kaplan Fund, and to the Fellows of The Frick Collection for their generous support of this publication.

Explanatory Note

Attribution

For the few paintings that cannot with certainty be attributed to specific artists, the following classifications are used: *Workshop of*, implying that the design may have been the master's but the execution was, in part at least, by an assistant; *Circle of*, implying that the unidentified artist probably had been trained by the master or influenced by close connection with him; and *Follower of*, implying that the unknown artist imitated the master's style but may have had no direct contact with him.

Dimensions

Measurements represent maximum stretcher or panel size. Dimensions are in inches, followed in parentheses by centimeters. Height precedes width.

Date of Acquisition

The date of each painting's acquisition is indicated by the first two digits of its accession number.

Historical Note

The Frick Collection was founded by Henry Clay Frick (1849–1919), the Pittsburgh coke and steel industrialist. At his death Mr. Frick bequeathed his New York residence and the most outstanding of his many artworks to establish a public gallery for the purpose of "encouraging and developing the study of the fine arts." Chief among his bequests, which also included sculpture, drawings, prints, furniture, porcelains, enamels, rugs, and silver, were 131 paintings. Forty-seven additional paintings have been acquired over the years by the Trustees from an endowment provided by the founder and from gifts and bequests.

Mr. Frick grew up in the vicinity of Pittsburgh. From an early age he was interested in art, and his acquisitions recorded over a span of forty years show a continuing development of knowledge and discernment. After initially concentrating on Salon pictures and works by the Barbizon school, he purchased his first Old Masters around the turn of the twentieth century. In the next decade he acquired many of the distinguished paintings that established the character of the Collection as it is seen today. A more extended account of Mr. Frick's collecting is included in the biographical essay "Henry Clay Frick, Art Collector," which appears as an introduction to Volume I of *The Frick Collection: An Illustrated Catalogue*.

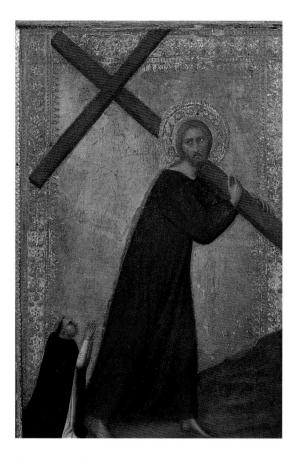

Barna da Siena Active around 1350

Though nothing certain is known of his life and even his name is in question, the master traditionally identified as Barna is firmly established on the basis of his frescoes in the Collegiata at San Gimignano as the leading Sienese painter in the years following the great plague of 1348.

Christ Bearing the Cross, with a Dominican Friar Tempera on poplar panel, $12 \ge 8^{1/2}$ (30.5 ≥ 21.6) Painted about 1350–60 Gift of Miss Helen C. Frick. 27.1.1

The attribution and dating of this remarkably affecting little panel are based on its close resemblance to the *Way to Calvary* fresco at San Gimignano. Unlike so many of Barna's contemporaries, the artist emphasizes Christ's sorrow rather than His physical pain. The diminutive Dominican monk kneeling at lower left is presumed to have commissioned the work, perhaps as a devotional image for his cell.

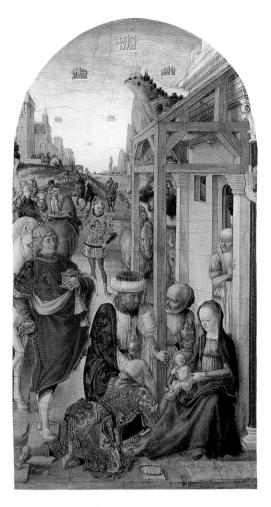

Lazzaro Bastiani d. 1512

Bastiani was born in Venice and achieved considerable prominence there. His rather conservative style is related to that of the Vivarini and to the work of Jacopo and Gentile Bellini.

Adoration of the Magi

Tempera on poplar panel, $20\frac{1}{2} \ge 11$ (52 ≥ 28) Painted probably in the 1470s. 35.1.130

During the fourteenth and fifteenth centuries the journey of the Magi to Bethlehem was commemorated by colorful processions with stops along the way to reenact highlights of the voyage. Bastiani depicts the Adoration as though it were such a pageant, in which lavishly costumed performers and their exotic beasts wind through the landscape. The climax of the narrative takes place before the stable as the Magi pay homage to the King of Kings.

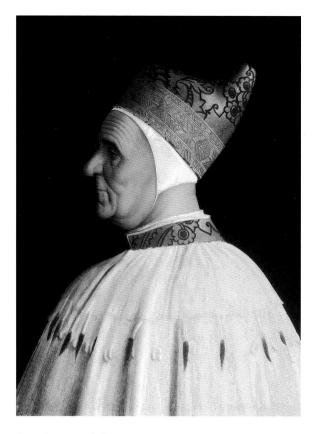

Gentile Bellini c. 1429-1507

Gentile and his brother Giovanni were trained in the studio of their father, Jacopo Bellini. As painter to the Republic of Venice, Gentile executed many official portraits and recorded in picturesque detail numerous pageants and ceremonies. In 1479–80 he was at the court of Sultan Mohammed II in Constantinople.

Doge Giovanni Mocenigo

Tempera on poplar panel, $25^{1}/2 \ge 18^{3}/4$ (64.8 ≥ 47.6) Painted probably between 1478 and 1485. 26.1.2

Despite the fact that a late inscription on this panel (now painted over) identified the subject as the Doge Andrea Vendramin, it seems virtually certain that the painting actually represents Vendramin's successor, Giovanni Mocenigo (1408–1485), who held various civil and military posts in Venice and its territories before being elected Doge in 1478. Mocenigo's features are recorded in several portraits preserved in Venice. The warm coloring and strong modeling of this work may reflect the influence of the artist's brother Giovanni.

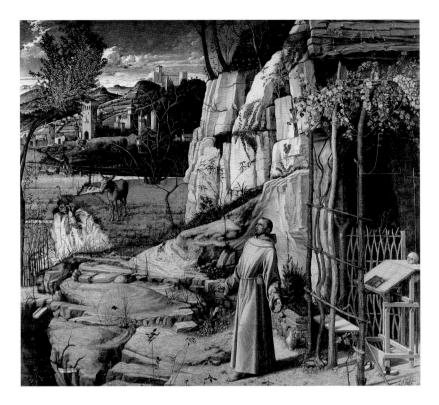

Giovanni Bellini c. 1430–1516

Giovanni Bellini began his career in the workshop of his father, Jacopo. In 1483 he succeeded his brother Gentile as painter to the Republic of Venice, and thereafter he was constantly employed by the state, as well as by Venetian churches and private patrons. He was one of the first Italian artists to master the oil technique of the northern European painters.

St. Francis in the Desert

Tempera and oil on poplar panel, 49 x 557/8 (124.4 x 141.9). Signed: IOANNES BELLINUS Painted about 1480. 15.1.3

St. Francis of Assisi (1181/82–1226), founder of the Franciscan order, is believed to have received the Stigmata—the wounds of Christ's Crucifixion—in 1224 during a retreat on Mount La Verna in the Apennines. It is probably this event that Bellini has represented here through the naturalistic yet transcendental imagery of rays of light flooding the foreground from an unseen source at upper left. The artist has given special importance to the landscape setting, with its animals, plants, and rock formations that reflect the imagery of early Franciscan literature.

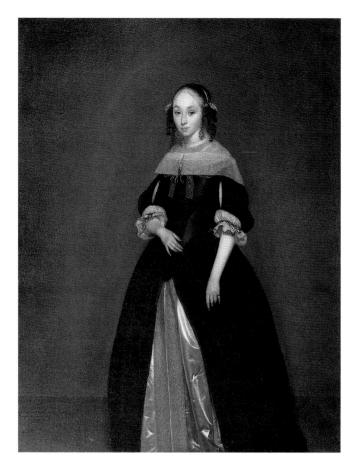

Gerard ter Borch 1617–1681

Ter Borch studied in his native Zwolle and then in Haarlem, where he painted the first of the genre scenes and portraits that made him famous. His extensive travels probably brought him to Spain, where he may have been influenced by Velázquez.

Portrait of a Young Lady Oil on canvas, 21¹/8 x 16 (53.7 x 40.6) Painted about 1665–70. 03.1.113

Small-scale portraits such as this were extremely popular in Holland during the second half of the seventeenth century. Characteristic of ter Borch's manner are the elegant proportions of the figure and the skillful depiction of light playing over rich fabrics. Substantially the same costume and pose are found in other portraits by ter Borch, suggesting that he painted from life only his subjects' heads and hands, adding costumes and backgrounds afterward.

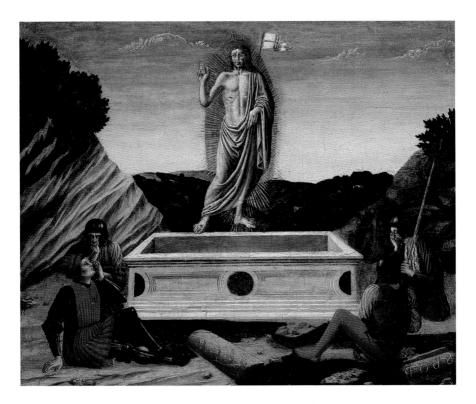

Francesco Botticini 1446/47-1498

Born in Florence, Francesco Botticini received his first training from his father, an artisan painter, and at age thirteen spent a brief apprenticeship in the workshop of Neri di Bicci. A document of 1469, referring to Botticini as dipintore, suggests that he had by then established his own workshop. A painter of monumental altarpieces, Botticini absorbed the influence of some of the leading Florentine painters of the period, among them, Verrocchio, Perugino, and Botticelli, as well as aspects of Flemish painting. Botticini and his workshop earned acclaim in his lifetime for the paintings they produced in a decorative artisan style.

The Resurrection

Tempera on poplar panel, $11^{1/4} \ge 13^{1/4} (28.5 \ge 33.7)$ Date unknown. 39.1.143

The austere dignity of the scene, with its simple composition, gives this small panel an exceptional sense of monumentality. In representing Christ as hovering in a *mandorla* above His tomb, the artist follows a Florentine tradition of fusing the events of the Resurrection and the Ascension. The painting is thought to be one of a series of subsidiary panels from a now-lost altarpiece.

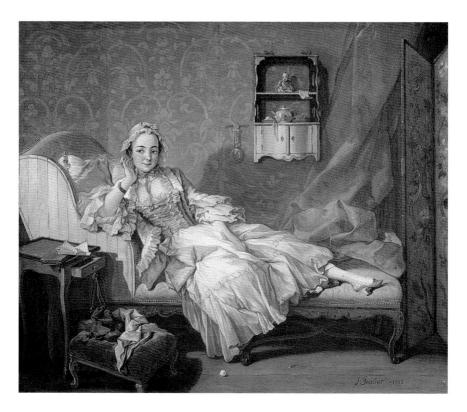

François Boucher 1703–1770

Born and trained in Paris, Boucher visited Italy at his own expense between 1728 and 1731 and was elected to the Academy in January 1734. He subsequently held high posts at both the Beauvais and Gobelins tapestry factories. Madame de Pompadour employed him for many commissions, and in 1765 he was named "Premier Peintre" to Louis XV. He also had a great influence on the decorative arts of his day.

Presumed Portrait of Madame Boucher Oil on canvas, 22¹/2 x 267/8 (57.2 x 68.3) Signed and dated: *f. Boucher.* 1743. 37.1.139

Traditionally considered to be a portrait of Marie-Jeanne Buzeau (1716–after 1786)—Boucher's twenty-seven-year-old wife and the mother of his three children—this meticulously described genre scene is more likely to be one of those "fashionable figures, with pretty faces" that contemporaries noted Boucher was "so good at." Furnishings such as the folding screen at right and the porcelain figurine and tea service on the étagère above reflect the vogue for imports in the latest *chinoiserie* taste.

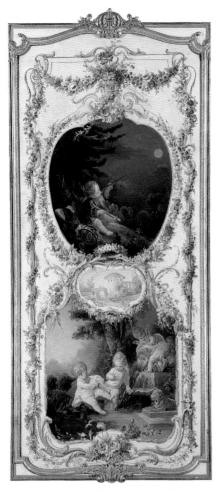

Astronomy and Hydraulics

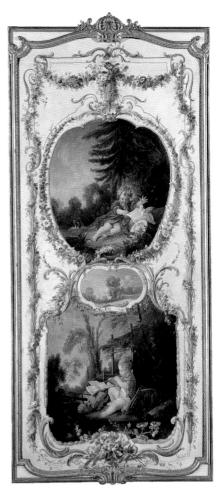

Poetry and Music

Boucher and Studio Oil on canvas: 85¹/2 x 85¹/2 x 201/2 (217.2 x

Oil on canvas: 85¹/2 x 38 (217.2 x 96.5); or 85¹/2 x 30¹/2 (217.2 x 77.5) Painted probably 1760–65 16.1.4–16.1.11

It has long been believed that this series of decorative panels was made by Boucher for an octagonal boudoir in Madame de Pompadour's Château de Crécy, an estate near Chartres that she acquired in 1746 and extensively refurbished during the following decade, before divesting herself of the property in 1757.

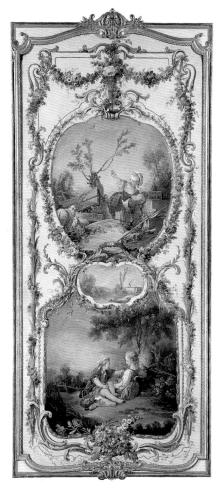

Fowling and Horticulture

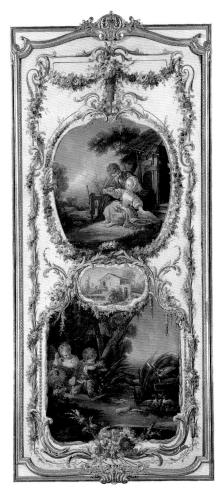

Fishing and Hunting

In fact, at least two of the scenes are based on compositions made *after* this date: *Tragedy* parodies Carle Van Loo's *Portrait of Mademoiselle Clairon as Medea*, shown at the Salon of 1759; and *Architecture* reprises an easel painting by Boucher, signed and dated 1761, today in the Musée d'Art et d'Histoire in Geneva. It seems likely therefore that this set of paintings, based indeed on models by Boucher, was executed in his workshop as a

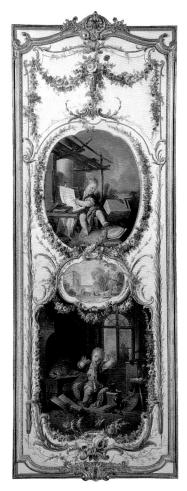

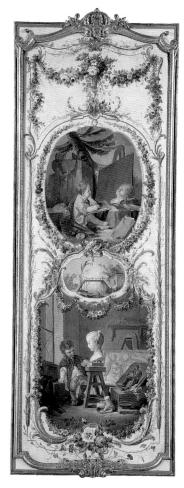

Architecture and Chemistry

Painting and Sculpture

prestigious commission for an as yet unidentified patron. Even though the panels were not painted for Madame de Pompadour, it was her passion for "les enfants de Boucher" (Boucher's children) that created the iconography of children humorously mimicking the occupation of adults—and such scenes appeared in many of the sculptures, ceramics, painted porcelains, and tapestries commissioned for her various residences.

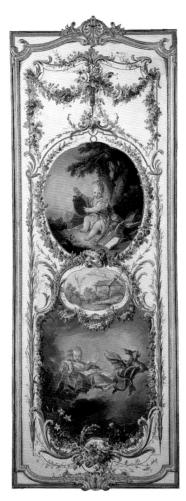

Comedy and Tragedy

Singing and Dancing

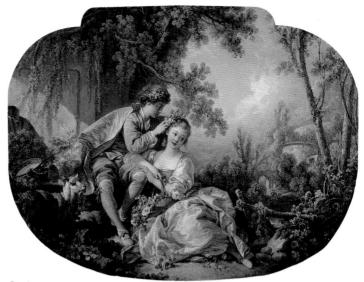

Spring

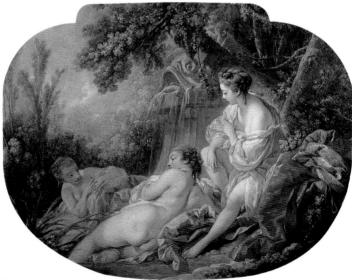

Summer

Boucher The Four Seasons

Oil on canvas, 22¹/2 x 28³/4 (57.2 x 73). Nos. 12, 14, 15, signed and dated: *f. Boucher* 1755. 16.1.12–16.1.15.

These four canvases, painted for Madame de Pompadour, probably were designed as overdoors for one of the Marquise's residences. Earlier representations of the seasons had usually depicted the labors performed at the various times of the year, but Boucher

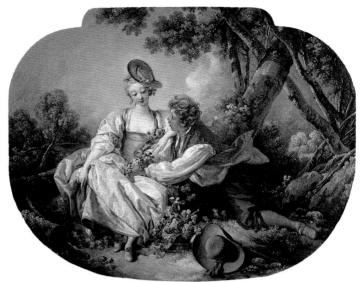

Autumn

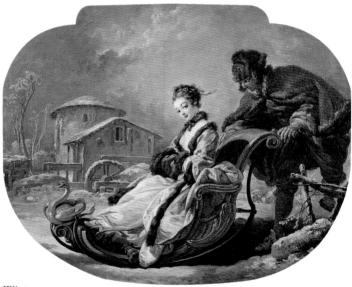

Winter

characteristically chose to illustrate pleasant pastimes instead, in the tradition of the *fêtes galantes* established by his great predecessor Watteau. Attempts to identify the lady in *Winter* as Madame de Pompadour and the central bather in *Summer* as Louise O'Murphy, the King's mistress, must remain inconclusive, as Boucher's women tend by the 1750s to fall into types, often resembling his wife.

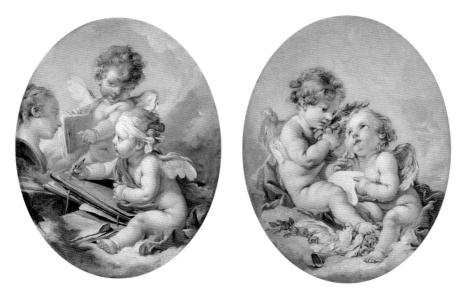

Boucher Drawing Poetry Oil on canvas, 15³/₄ x 12⁷/₈ (40 x 32.7) Painted about 1760. 16.1.16 and 16.1.17

Though companion pieces, these two works seem to have been painted by different artists. *Drawing*, richer and warmer in coloring, may be by Boucher himself. *Poetry*, which is flatter in form and relies more on line than color and light for modeling, is probably by an assistant.

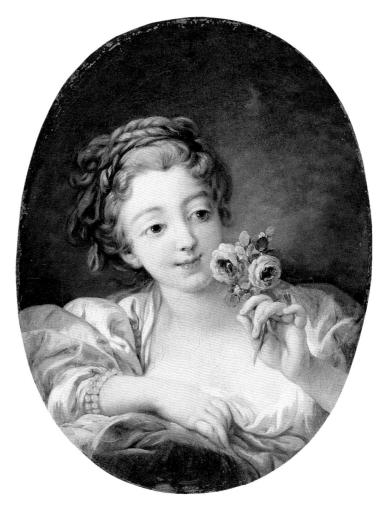

Boucher Girl with Roses Oil on canvas, $21^{1/2} \ge 16^{3/4} (54.6 \ge 42.5)$

Painted probably in the 1760s. 16.1.18

Elements of the pose and coiffure in this composition, which perhaps was intended to represent the sense of smell, seem to derive from certain paintings by Boucher representing *Vertumnus and Pomona*, works that were reproduced in tapestry.

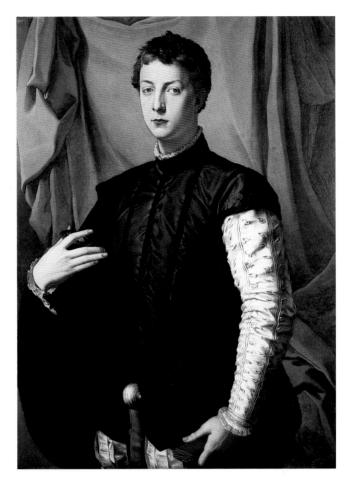

Agnolo Bronzino 1503–1572

Agnolo di Cosimo di Mariano, called Bronzino, studied under Pontormo and later collaborated with him. As court painter to Duke Cosimo I de' Medici, Bronzino became the foremost portraitist of Florence. He also executed religious and allegorical subjects as well as decorations for Medici festivities.

Lodovico Capponi

Oil on poplar panel, 457/8 x 33³/4 (116.5 x 85.7) Painted probably between 1550 and 1555. 15.1.19

This elegant young aristocrat has been identified as Lodovico Capponi (b. 1533), a page at the Medici court. As was his custom, he wears black and white, his family's armorial colors. His right index finger tantalizingly conceals the image on the cameo he holds, revealing only the inscription SORTE (fate or fortune)—an ingenious allusion to the obscurity of fate.

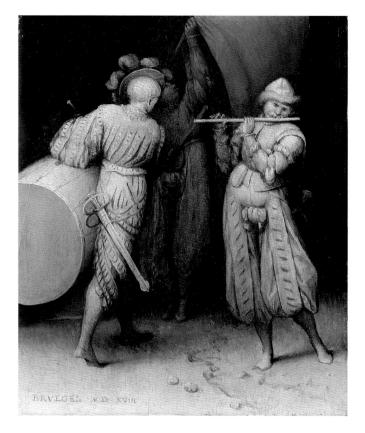

Pieter Bruegel the Elder Active 1551–1569

The earliest record of Bruegel is his entry into the Antwerp painters' guild in 1551. He traveled to Italy around 1552 and by 1555 was back in Antwerp, where he supplied the engraver Hieronymus Cock with designs in the style of Bosch. In 1563 he settled in Brussels. Bruegel's landscape paintings and peasant scenes had a powerful and lasting influence in the Netherlands.

The Three Soldiers

Oil on oak panel, 8 x 7 (20.3 x 17.8) Signed and dated: BRVEGEL M.D. [L?]XVIII. 65.1.163

This little panel, once in the collection of Charles I of England, represents a trio of *Landsknechte*, the mercenary foot soldiers who were a popular subject for printmakers in the sixteenth century. Bruegel may have executed it as a model for an engraving, though none is known, or simply as a cabinet piece. Lacking the lusty realism that characterizes his genre scenes, this work, along with a small number of other grisailles, perhaps reflects in its attenuated and elegant figures the influence of contemporary Italian painters.

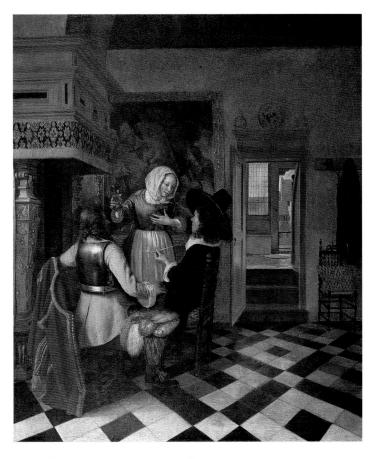

Hendrik van der Burgh, Attributed to Active 1649-After 1669

Van der Burgh was enrolled as a foreigner in the painters' guild of Delft in 1649 and later worked in Leyden and Amsterdam. He painted chiefly interior scenes and was strongly influenced by Pieter de Hoogh.

Drinkers before the Fireplace

Oil on canvas, 30¹/2 x 26¹/8 (77.5 x 66.3) Painted perhaps in the 1660s. 18.1.78

Both de Hoogh, to whom the present canvas was long attributed, and van der Burgh specialized in the depiction of intimate domestic scenes like this one. The same doorway, outer room, and distant houses appear in de Hoogh's *Duet* of 1670, but the figures and such distinctive features as the erratic perspective of the floor are more typical of van der Burgh.

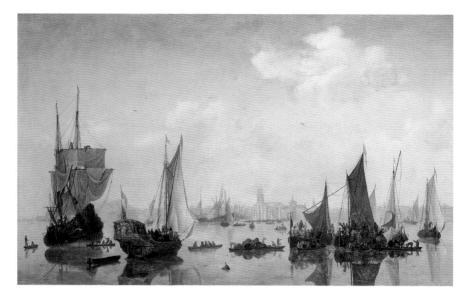

Jan van de Cappelle, Follower of

Van de Cappelle (c. 1624–1679) was born in Amsterdam, where he painted seascapes and winter landscapes from about 1645 to the mid-1660s. His calm marine and river scenes inspired a number of imitators.

A View of the River Maas before Rotterdam Oil on oak panel, $36^{1/2} \ge 61 (92.7 \ge 154.9)$ Date unknown. 06.1.20

Among the landmarks identifying the city in the background as Rotterdam is the Gothic St. Laurenskerk, shown at center without the wooden steeple that was removed in 1645. This painting resembles in a general way the stately compositions of becalmed vessels that were a specialty of van de Cappelle, but the distant city view and other uncharacteristic elements suggest that it was done by a follower.

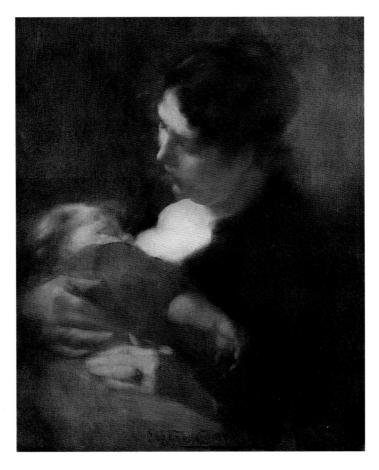

Eugène Carrière 1849–1906

Carrière worked as a lithographer in Strasbourg and a commercial designer in Saint-Quentin before moving to Paris, where he studied at the École des Beaux-Arts and subsequently under Cabanel. With Rodin, Puvis de Chavannes, and others he founded in 1890 the Société Nationale des Beaux-Arts, where he exhibited regularly.

Motherhood

Oil on canvas, 22 x 18¹/4 (55.8 x 46.3) Signed: *Eugène Carrière*. Painted probably in the 1880s 16.1.21

Carrière painted many pictures on the theme of motherhood, often using friends and relatives as models. His wife and one of their numerous children are portrayed in the Frick canvas. The vaporous browns and grays, typical of Carrière's work, evoke the poetic imagery of the contemporary Symbolists, as well as the sculptural style of Rodin.

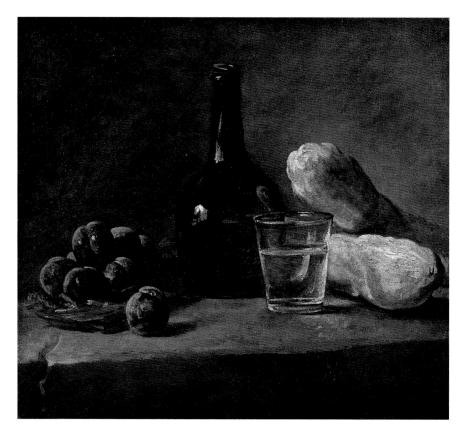

Jean-Baptiste-Siméon Chardin 1699–1779

Chardin, the son of a cabinetmaker, was born and trained in Paris. His official recognition began in 1728 with his admission to the Academy as a genre painter. Subsequently Louis XV awarded him commissions, a pension, and an apartment in the Louvre. Chardin's still lifes and middle-class domestic scenes were esteemed by contemporary collectors throughout Europe.

Still Life with Plums

Oil on canvas, 17³/4 x 19³/4 (45.1 x 50.2) Signed: *chardin*. Painted probably about 1730. 45.1.152

Speaking of Chardin's still lifes, Diderot praised the "magic" of the artist's realism as well as his subtle color harmonies. Other contemporary critics admired Chardin's mastery of the varying effects of light on the surfaces of the familiar household objects with which he usually constructed his solidly designed compositions.

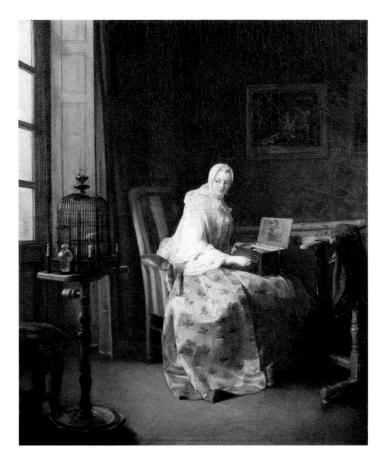

Chardin Lady with a Bird-Organ Oil on canvas, 20 x 17 (50.8 x 43.2) Painted in 1751(?). 26.1.22

This characteristically unpretentious scene of everyday life in a comfortable eighteenth-century household represents a lady—possibly Madame Chardin—training a caged canary to sing by playing an instrument known as a bird-organ. The Frick canvas is one of several versions of a composition commissioned in 1751 by Louis XV.

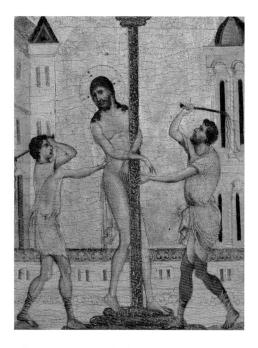

Cimabue (Cenni di Peppo) c. 1240-c. 1302

Although the date and place of his birth are unknown, surviving accounts indicate that Cimabue began his career before 1273 and worked in Assisi, Florence, Rome, and Pisa. A painter and mosaicist, his oeuvre incorporates elements of Byzantine painting as well as Classical and contemporary sculpture, especially that of Nicola Pisano. Considered one of the founders of Italian Renaissance painting, Cimabue's monumental style influenced many younger artists, including Duccio and Giotto.

The Flagellation of Christ

Tempera on poplar panel, 9³/4 x 7⁷/8 (24.7 x 20) Painted in c. 1280. 50.1.159

Ascribed alternately to Cimabue, Duccio, or an unknown Tuscan artist, the panel's authorship was confirmed in 2000 when a panel of the *Virgin and Child* (now in the National Gallery, London) having similar dimensions, haloes, and craquelure patterns as the Frick panel—was discovered and identified to be by Cimabue. The subjects of these panels suggest that they may have been part of a devotional diptych featuring scenes from Christ's Passion and the Last Judgment. The attribution of these two panels to Cimabue —an artist best known for creating large-scale frescoes and altarpieces—enables us to assess the artist's ability to compose elegantly on a small scale.

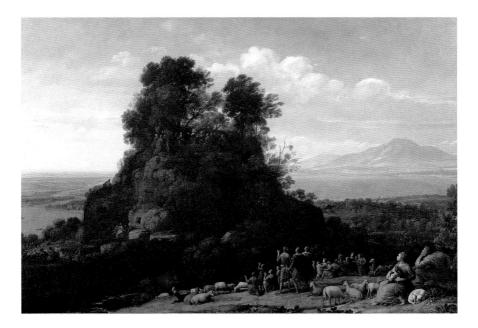

Claude Lorrain 1600–1682

Claude Gellée, who was called Lorrain after his native province of Lorraine, settled as a youth in Rome and spent nearly all his adult life there. His early work was chiefly in fresco, of which little remains, but his fame is based on landscape canvases. Patronized principally by the Italian nobility, he also enjoyed an international reputation.

The Sermon on the Mount

Oil on canvas, 67¹/2 x 102¹/4 (171.4 x 259.7) Painted in 1656. 60.1.162

Christ, surrounded by the Twelve Apostles, is shown preaching to the multitude from the summit of Mount Tabor (Matthew 5:1–2). The artist has compressed the geography of the Holy Land, placing on the right the distant Mount Lebanon and the Sea of Galilee, with the towns of Tiberias and Nazareth on its shores, and on the left the Dead Sea and the river Jordan. The small foreground figures enhance the dramatic spatial effects of the vast landscape. The painting was executed for François Bosquet, Bishop of Montpellier, and later entered the collection of William Beckford at Fonthill.

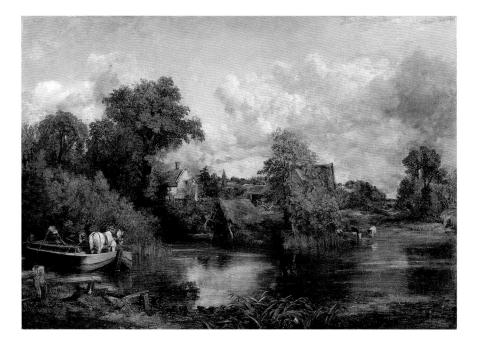

John Constable 1776–1837

Constable left his native Suffolk in 1799 to study at the Royal Academy, of which he became an associate in 1819 and a full member only in 1829. His landscapes, which depict chiefly the Suffolk countryside, had a deep influence on his contemporaries, particularly the French. His elaborately finished exhibition pieces were based on numerous sketches painted outdoors directly from nature.

The White Horse

Oil on canvas, 51³/₄ x 74¹/₈ (131.4 x 188.3) Signed and dated: *John Constable*, A.R.A / London F. 1819 43.1.147

The painting depicts a tow-horse being ferried across the river Stour in Suffolk at a point near Dedham where the towpath switched banks. Constable, who described the scene as "a placid representation of a serene, grey morning, summer," went on in later years to comment: "There are generally in the life of an artist perhaps one, two, or three pictures, on which hang more than usual interest—this is mine."

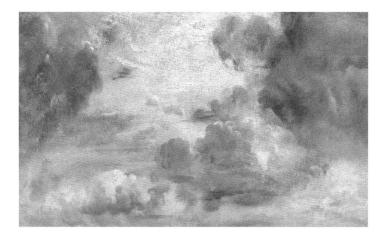

Constable

Cloud Study

Oil on paper laid down on board, 11¹/2 x 19 (29 x 48) Painted probably about 1822. Bequest of Henrietta E. S. Lockwood in memory of her father and mother, Ellery Sedgwick and Mabel Cabot Sedgwick, 2000. 2001.3.133

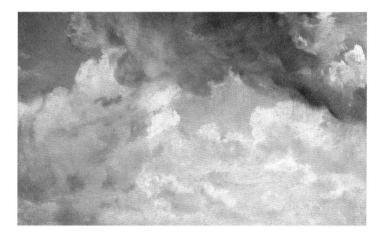

Cloud Study

Oil on paper laid down on board, 11¹/2 x 19 (29 x 48) Painted probably about 1822. Bequest of Henrietta E. S. Lockwood in memory of her father and mother, Ellery Sedgwick and Mabel Cabot Sedgwick, 2000. 2001.3.134

These sketches are pure cloud studies, of which Constable made estimated one hundred between October 1820 and 1822. These two were done around noon. Although none of Constable's cloud studies were ever used in his finished paintings, they played an important part in the evolution of his skies.

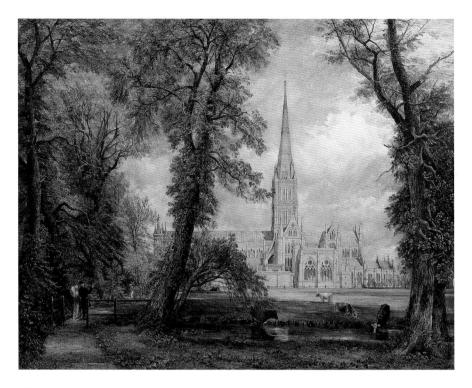

ConstableSalisbury Cathedral from the Bishop's GardenOil on canvas, 35 x 441/4 (88.9 x 112.4)

Oil on canvas, 35 x 44¹/4 (88.9 x 112.4) Signed and dated: *John Constable. f. London.* 1826 08.1.23.

Constable painted several views of the south façade of Salisbury Cathedral for his intimate friends Dr. John Fisher, Bishop of Salisbury, and the Bishop's nephew Archdeacon John Fisher, who had purchased *The White Horse* in 1819. In this version two favorite subjects of nineteenth-century artists—a medieval ecclesiastical monument and a dramatic landscape—are particularly well united through the arrangement of tree trunks and branches echoing the rising lines of the cathedral spire.

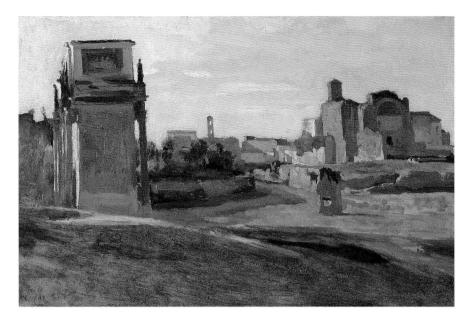

Jean-Baptiste-Camille Corot 1796–1875

Corot was born in Paris and studied there before leaving in 1825 for a three-year sojourn in Italy. After his return he worked in the Île-de-France and the Forest of Fontainebleau, and later in life he traveled and painted throughout much of France and elsewhere in Europe. He exhibited frequently in the Salons and won many honors.

The Arch of Constantine and the Forum, Rome Oil on paper, mounted on canvas, 105/8 x 161/2 (27 x 41.9) Painted in 1843 Gift of Mr. and Mrs. Eugene Victor Thaw. 94.1.175

Corot made three trips to Italy, the last in 1843, the probable date of this oil sketch. The artist must have painted it while at the site, facing northwest along the main axis of the Roman Forum. A late afternoon sun illuminates the famous monuments, which include the Arch of Constantine, the Arch of Titus, the ruins of the Temple of Venus and Rome, the remains of an ancient fountain known as the Meta Sudans, and the distant campanile of the Palazzo Senatorio on the Campidoglio. A crystalline light and the cool, pale hues of green, blue, and buff suggest that the season is late spring or early summer.

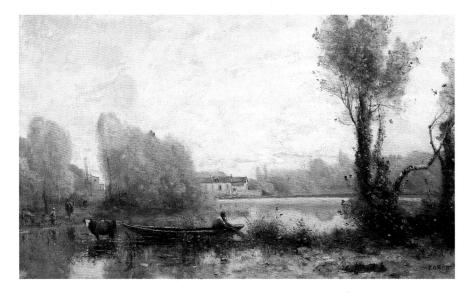

Corot Ville-d'Avray

Oil on canvas, 17¹/4 x 29¹/4 (43.8 x 74.3) Signed: COROT. Painted about 1860. 98.1.27

The house at the center of this painting is probably the one Corot bought from the poet Estienne at the Ville-d'Avray, a community west of Paris where his father also had a country house. The village and its pond recur frequently in the artist's work.

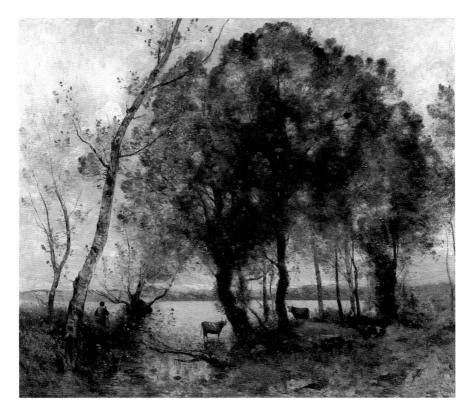

Corot The Lake

Oil on canvas, 52³/8 x 62 (133 x 157.5) Signed: COROT. Painted in 1861. 06.1.25

Corot exhibited *The Lake* in the Salon of 1861. Though some critics were beginning to question the artist's misty late style—Thoré, for example, complained, "One is not sure where one is and one has no idea where one is going"—others admired the somber, nearly monochromatic coloring and broadly massed design of this painting. One writer called it "a ravishing landscape, simple in composition and full of grandeur."

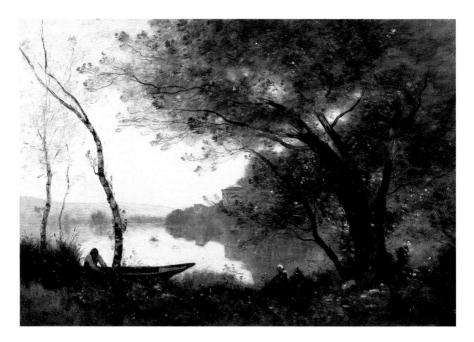

Corot The Boatman of Mortefontaine Oil on canvas, 24 x 353/8 (60.9 x 89.8) Signed: COROT. Painted between 1865 and 1870. 03.1.24

Though inspired by the park of Mortefontaine outside Paris, Corot's landscape is to a large degree imaginary. To enhance the poetic mood of the scene he included on the far shore an Italianate *tempietto*, which does not appear in his closely related *Souvenir de Mortefontaine* of 1864 in the Louvre.

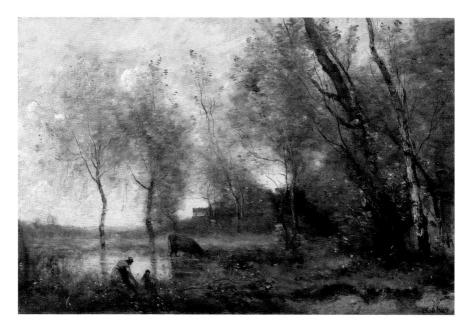

Corot The Pond

Oil on canvas, 19¹/4 x 29 (48.8 x 73.6) Signed: COROT. Painted between 1868 and 1870. 99.1.26

This unlocated and probably imaginary landscape contains elements found repeatedly in Corot's work, especially between 1860 and 1870: graceful stands of plumelike trees, waters reflecting luminous skies, a few small figures, and cattle.

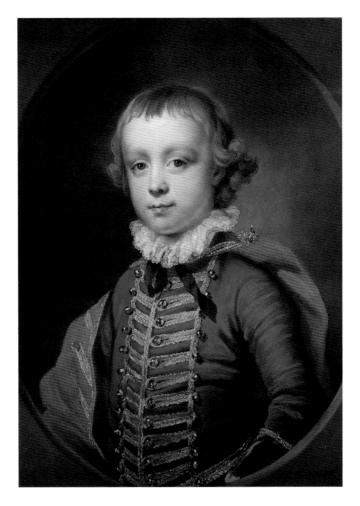

Francis Cotes 1726-1770

A native of London, Cotes was a portraitist known chiefly for pastels, though he also worked in oils. He was trained by Knapton, and his style shows the influence of such contemporary pastelists as Carriera, Liotard, and Latour. In 1768 he became a founding member of the Royal Academy.

Francis Vernon

Pastel on paper affixed to canvas, $24 \ge 177/8$ ($61 \ge 45.5$) Signed and dated: *FCotes* px^t : 1757. 15.1.137

Done three years before the boy's death in 1760, this portrait shows Master Francis Vernon of Orwell Park, Suffolk, at the age of five. Through such works Cotes achieved considerable success with pastel portraiture in England at a time when the medium was more popular on the Continent.

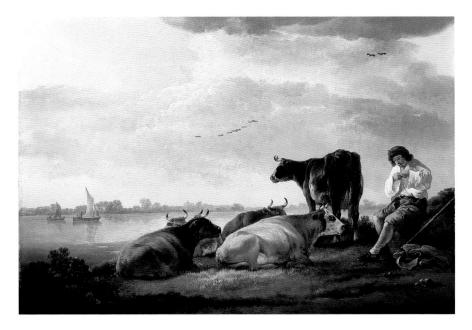

Aelbert Cuyp 1620–1691

Cuyp was born in Dordrecht and spent his entire life there. His early pictures recall those of his father, Jacob Gerritsz. Cuyp, and of Jan van Goyen. In the 1640s, under the influence of the Italianized landscapes of Jan Both and others, he developed the luminous style that characterizes his best-known works. He produced landscapes and occasional portraits until the mid-1660s, when he appears to have ceased painting.

Cows and Herdsman by a River

Oil on oak panel, 19³/₄ x 29¹/₄ (50.2 x 74.3) Signed: *A. cuyp*. Painted probably in the 1650s. 02.1.28

The ruins on the horizon to the left of center may be those of the Huis te Merwede, a castle on the river Merwede a mile to the east of Dordrecht. Cuyp is celebrated for landscapes such as this, which infuse realistic topography with an Arcadian spirit.

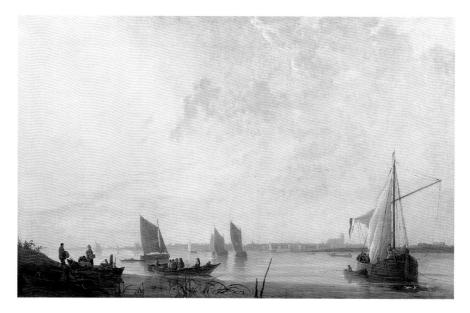

Cuyp Dordrecht: Sunrise

Oil on canvas, 40¹/8 x 63³/8 (102 x 161) Signed: *A. cuyp.* Painted about 1650. 05.1.29

This early morning scene, with its golden expanse of sky and water, is one of Cuyp's most ambitious attempts to render light and atmosphere. The painting may ultimately reflect the influence of Claude Lorrain, whose landscapes impressed many Dutch artists. Cuyp depicts Dordrecht as seen from the north, looking across the river Merwede. Most prominent among the recognizable buildings is the Groote Kerk, the church on the horizon to the left of the large boat in the foreground.

Cuyp River Scene

Oil on oak panel, 23¹/8 x 29¹/8 (58.7 x 74) Signed: *A. cuyp*. Date unknown. 09.1.30

Scenes of vessels plying the inland waterways around Dordrecht were among Cuyp's specialties and permitted him to exploit intricate effects of light, such as those on the sails in this panel. Ferries of the type depicted in the right foreground were among the chief means of public transportation in the Netherlands until the expansion of stagecoach routes in the eighteenth century.

Charles-François Daubigny 1817–1878

The son of a Paris landscape painter, Daubigny studied with Delaroche and achieved his first great success when Napoleon III bought his 1853 Salon entry. Influenced by the Barbizon painters to work directly from nature, he found many motifs for his landscapes in the countryside around Paris and during frequent trips through Brittany, Normandy, and Picardy.

The Washerwomen

Oil on canvas, 207/8 x 311/2 (53 x 80) Signed: *Daubigny*. Painted probably between 1870 and 1874 96.1.32

The subject of women washing clothes by a stream is one Daubigny repeated many times, often using sites along the river Oise northwest of Paris. The present canvas, the earliest of Mr. Frick's acquisitions bequeathed to the Collection, shows in the sketchy brushwork of the landscape the influence of the contemporary Impressionists.

Daubigny D

Dieppe

Oil on canvas, 26³/₈ x 39³/₄ (67 x 101) Signed and dated: *Daubigny* 1877. 04.1.131

Unlike Turner, whose large view of Dieppe in The Frick Collection records the picturesque bustle of that ancient Norman port, Daubigny chose to depict the somber industrial side of the city. The tower and cupola prominently silhouetted against the sky in both paintings are those of the church of St.-Jacques. The broad, vigorous application of paint in this canvas is typical of Daubigny's last period and suggests affinities with the early work of Manet and Cézanne.

Gerard David Active 1484–1523

David was born at Oudewater, near Gouda. By 1484, he was in Bruges, where after the death of Memling in 1494 he became chief painter of the city Documents show him working in Antwerp in 1515, but his death is recorded in Bruges.

The Deposition

Oil on canvas, 56¹/8 x 44¹/4 (142.5 x 112.4) Painted about 1510–15. 15.1.33

The somber dignity of the mourning figures and the austere simplicity of this composition greatly impressed David's contemporaries, who produced a number of copies and variants of *The Deposition*. This work is among the earliest extant northern European paintings executed on canvas in oil, rather than tempera, and is also one of the first in which the visual qualities of the oil medium are fully realized—most notably in the subtle ranges of the cold but vibrant tones and in the finely rendered details of the extensive landscape.

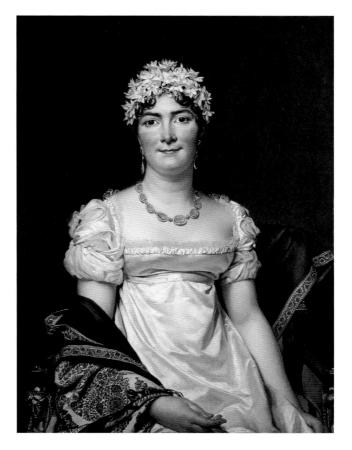

Jacques-Louis David 1748–1825

Born in Paris, David won the Prix de Rome in 1774 and the next year began a five-year residence in Italy. An ardent supporter of the Revolution and subsequently of Napoleon, he was a virtual dictator of the arts until the Emperor's downfall. Best known as a history painter, he also was extremely successful as a portraitist.

Comtesse Daru

Oil on canvas, 321/8 x 255/8 (81.6 x 65.2) Signed and dated: *L. David / 1810.* 37.1.140

In 1802 Alexandrine-Thérèse Nardot (d. 1815) married Pierre-Antoine-Noël Bruno, Comte Daru, who served as Secretary of State and Minister of War under Napoleon. David painted her portrait secretly as a surprise gift for the Count, who had helped him collect payment for *Le Sacre*, his vast painting of the coronation of Napoleon and Josephine. The writer Stendhal, who was in love with his cousin Daru's wife, recorded that David signed the finished work at four o'clock on March 14, 1810.

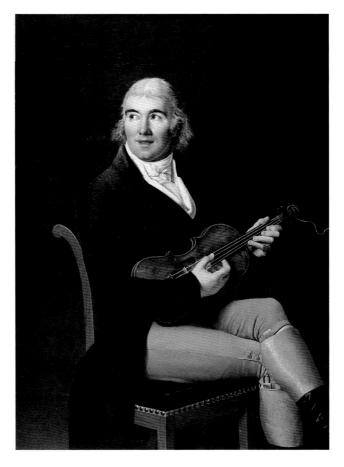

Césarine-Henriette-Flore Davin-Mirvault 1773–1844

Madame Davin-Mirvault, a native Parisian, was a pupil of David. She exhibited paintings, mostly portraits, in the Salons and won medals and considerable critical acclaim. During the Restoration she ran a school for ladies which specialized in miniature painting.

Antonio Bartolomeo Bruni

Oil on canvas, 50 x 37³/4 (129.2 x 95.9) Painted probably in 1804. 52.1.160

Composer, musician, and conductor, Antonio Bruni (1751–1821) was born at Cuneo in Piedmont but spent much of his life in Paris. During the Revolution he was an associate of David, to whom this work once was attributed. Madame Davin-Mirvault also knew Bruni, for he occasionally performed at receptions in her house. The direct, lively personality captured on this canvas, which was exhibited in the Salon of 1804, resembles that of the Comtesse Daru as recorded in David's portrait of her.

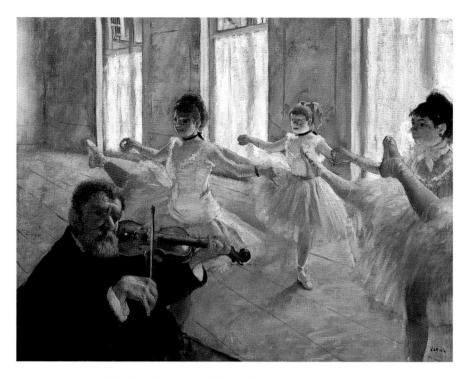

Hilaire-Germain-Edgar Degas 1834–1917

Born in Paris, Degas studied at the École des Beaux-Arts and exhibited at the Salons from 1865 until 1870. In 1872 he spent several months in New Orleans, and later in life he traveled on the Continent, in England, and in North Africa. His varied subjects, motifs drawn largely from urban life, included dancers, working girls, women bathing, and racehorses.

The Rehearsal

Oil on canvas, 18³/₄ x 24 (47.6 x 60.9) Signed: *Degas*. Painted probably in 1878 or early 1879 14.1.34

In his choice of ballet subjects Degas generally avoided dramatic moments of stage performance in favor of rehearsal scenes such as this one, which is probably the *École de danse* shown at the fourth exhibition of Impressionists in 1879. The blank, ordinary faces of the young dancers and their conventionalized movements contrast poignantly with the dark, brooding figure of the old violinist.

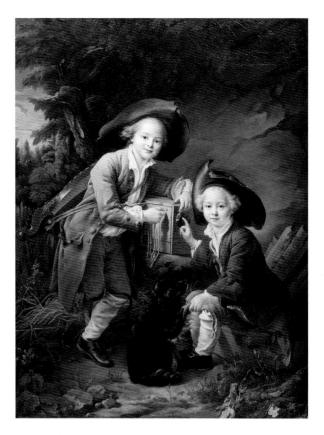

François-Hubert Drouais 1727–1775

Drouais was of Norman extraction but spent all his life in and around Paris. In 1757 he executed his first Royal commission, and the following year he was received as a full member in the Academy. Succeeding Latour and Nattier, Drouais became the prominent French portraitist of the mid-eighteenth century, painting courtiers, foreign aristocrats, writers, and fellow artists.

The Comte and Chevalier de Choiseul as Savoyards Oil on canvas, 547/8 x 42 (139.4 x 106.7) Signed and dated: *Drouais le fils* / 1758. 66.1.164

The standing boy with a hurdy-gurdy at his back is Marie-Gabriel-Florent-Auguste, Comte de Choiseul-Beaupré (1752–1817). Beside him, pointing to a peep-show box, sits his younger brother, Michel-Félix-Victor, Chevalier de Choiseul-Daillecourt (1754–1815). In costuming his subjects as Savoyards, the itinerants from Savoy who wandered over France working at odd jobs and in street fairs to support the families they left at home, Drouais probably intended to depict the brothers as models of filial devotion.

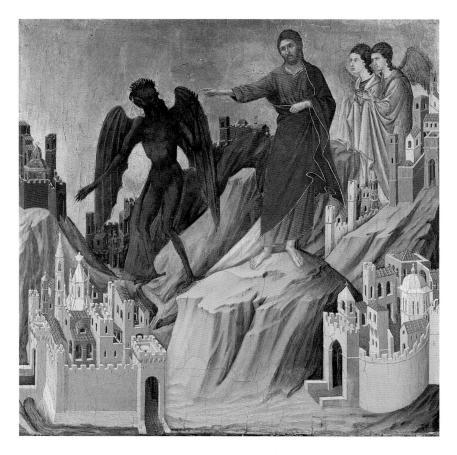

Duccio di Buoninsegna c. 1255–1319

Though Duccio was the leading Sienese master of his time, little is known of his life. He is first mentioned in a document of 1278, and in 1285 he received a commission for a painting assumed to be the Rucellai Madonna now in the Uffizi. His greatest work is the Maestà, a huge altarpiece commissioned in 1308 and carried to the Duomo of Siena in solemn procession on June 9, 1311.

The Temptation of Christ on the Mountain Tempera on poplar panel, 17 x 181/8 (43.2 x 46) Painted between 1308 and 1311. 27.1.35

Christ is shown rejecting the devil, who offers Him "all the kingdoms of the world" if He will worship him (Matthew 4:8–11). Duccio retains medieval conventions in representing the figures as large and the spurned kingdoms as small, thus suggesting a scale of relative values rather than naturalistic proportions. This panel is one of a series of scenes from the life of Christ painted on the reverse of Duccio's *Maestà*.

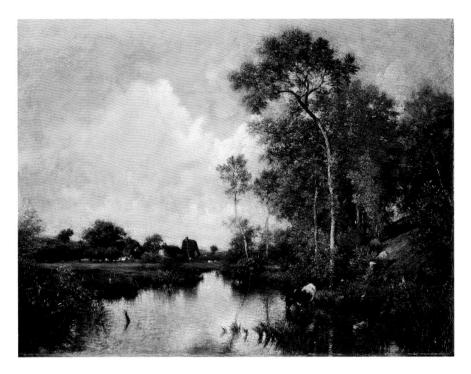

Jules Dupré 1811-1889

Dupré was born in Nantes and went to Paris around 1832. He exhibited in the Salons and associated with painters of the Barbizon group, including Rousseau, Troyon, and Daubigny.

The River Oil on canvas, 17 x 23 (43.2 x 58.4) Date unknown. 97.1.36

During a visit to England in 1834 Dupré met Constable, whose work strongly affected his style. The influence of the older painter's oil sketches is evident in this canvas, where short, broken brush strokes are skillfully employed to capture evanescent effects of light and atmosphere.

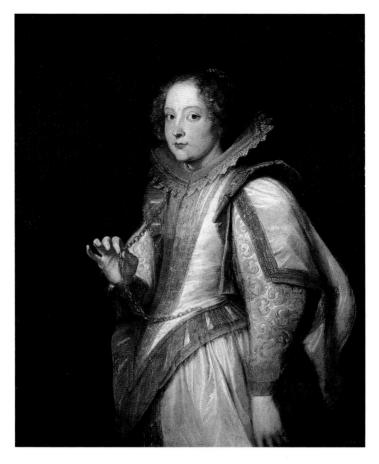

Sir Anthony Van Dyck 1599–1641

Van Dyck was a native of Antwerp, where he was apprenticed to Hendrik van Balen and later served as Rubens's chief assistant. He visited London in 1620 and worked in Italy from 1621 until 1627, when he returned to Antwerp. From 1632 until his death he was active chiefly in England.

Marchesa Giovanna Cattaneo

Oil on canvas, 40³/8 x 34 (102.6 x 86.4) Painted between 1622 and 1627. 07.1.41

Giovanna Battista Cattaneo, traditionally identified as the subject of this portrait, belonged to a Genoese family that included doges, cardinals, scholars, and statesmen. The heavy gold chain *(catena)* she so conspicuously displays probably is a play on her family name, which may also be reflected in the C-shaped scrolls embroidered on her sleeves. The abrupt termination of the figure suggests that the portrait has been cut down from a larger size.

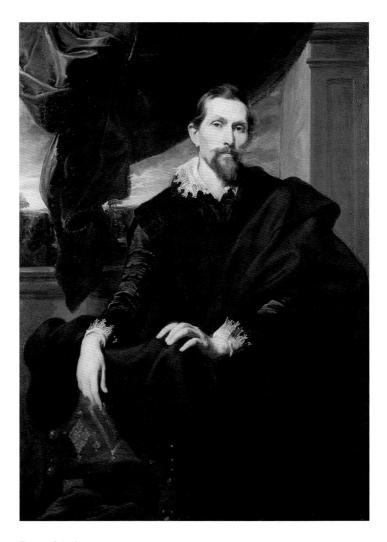

Van Dyck

Frans Snyders Oil on canvas, 56¹/8 x 41¹/2 (142.5 x 105.4) Painted about 1620. 09.1.39

Frans Snyders (1579–1657) was a celebrated and prolific painter of still lifes, animals, and hunting scenes, and often assisted Rubens in those capacities. He was an intimate friend of Van Dyck, who also depicted him in an etching. This painting and its pendant of Margareta Snyders executed in Antwerp are much closer to Rubens's style than the works of Van Dyck's later English period.

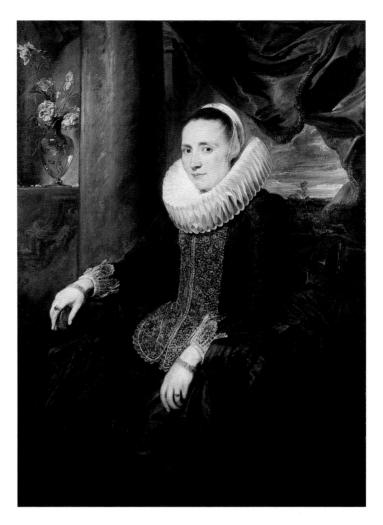

Van Dyck Margareta Snyders Oil on capyas 511/2 x 391/9 (130.5

Oil on canvas, 51¹/₂ x 39¹/₈ (130.7 x 99.3) Painted about 1620. 09.1.42

Margareta de Vos was a sister of the Antwerp painters Cornelis and Paul de Vos, both of whom occasionally worked for Rubens. She married Frans Snyders in 1611. Recognizable among the blossoms at upper left in her portrait are a daffodil, a poet's narcissus, and poppies, all flowers sacred to Ceres or her daughter Proserpina and symbolic of sorrow and death. Their presence here suggests that the couple may have been in mourning, possibly for a young daughter.

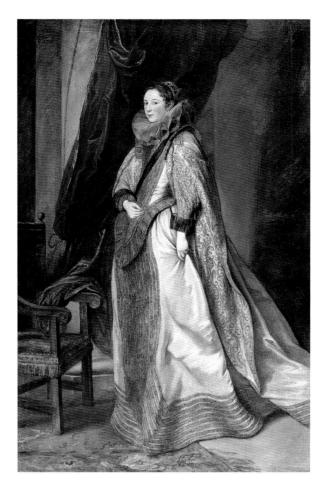

Van Dyck Portrait of a Genoese Noblewoman (formerly thought to be Paola Adorno, Marchesa di Brignole Sale) Oil on canvas, 907/8 x 615/8 (230.8 x 156.5) Painted between 1622 and 1627, 14.1.43

The light tonality of this portrait, painted on a yellow ground, is unusual for Van Dyck. The subject's face, set off by a blue-gray neck ruff, and her white satin dress richly embroidered in gold are painted in an illusionistic style, while the red curtain, rug, and background are rendered more summarily. The composition of the portrait, with an elongated figure standing in front of a cascading curtain, typify Van Dyck's work of his Italian period. Once thought to be the Duchess of Savoy and later Paola Adorno (the first wife of Anton Giulio Brignole-Sale, who also sat for Van Dyck), the sitter remains unidentified. One possibility is Giovanna Battista Cattaneo, the subject of another portrait by Van Dyck in The Frick Collection.

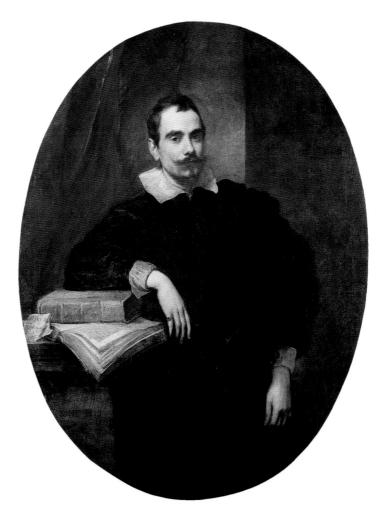

Van Dyck Ottaviano Canevari Oil on canvas, 51¹/4 x 39 (130.2 x 99.1) Painted probably in 1627. 05.1.38

Ottaviano Canevari was a Genoese magistrate and Senator and the brother of Demetrio Canevari, a celebrated physician, writer, and bibliophile who was thought to be the subject of this portrait until cleaning uncovered Ottaviano's name on the letter at left. When Demetrio died in 1625 he bequeathed in trust a vast library and named Ottaviano as executor, which may explain why Van Dyck included in the painting volumes by Hippocrates and Aristotle.

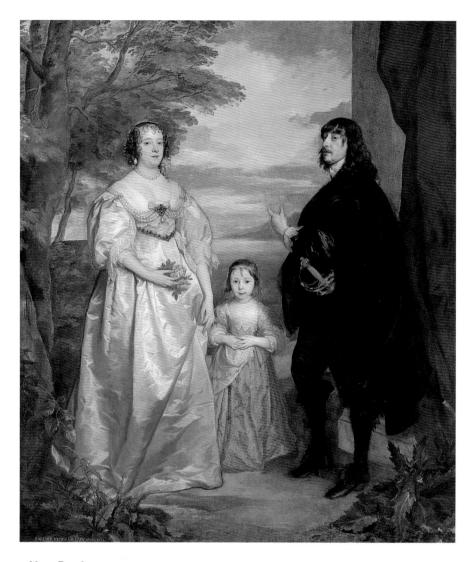

Van Dyck James, Seventh Earl of Derby, His Lady and Child Oil on canvas, 97 x 841/8 (246.4 x 213.7) Painted between 1632 and 1641. 13.1.40

> This imposing work, typical of the large group portraits Van Dyck painted during his last English period, represents James Stanley, seventh Earl of Derby, with his wife, Charlotte de la Trémoille, and one of their daughters. The Earl was a writer of history and devotional works as well as a Royalist commander at the time of the Civil War. He was captured and executed by Commonwealth forces in 1651. During the war his wife became famous for her spirited defense of Lathom House, the Derbys' country seat.

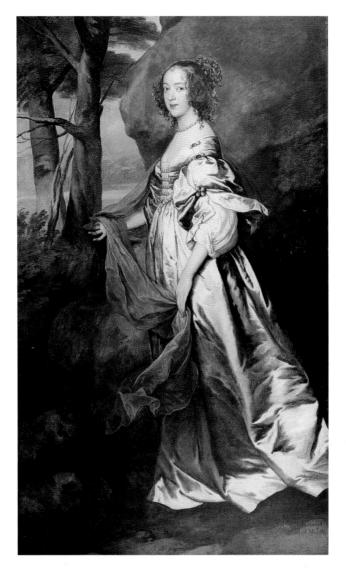

Van Dyck Anne, Countess of Clanbrassil Oil on canvas, 83¹/₂ x 50¹/₄ (212.1 x 127.6) Painted probably in 1636. 17.1.37

> Lady Anne Carey (d. 1689), daughter of the second Earl of Monmouth, was married in 1635 to James Hamilton, second Viscount Claneboye, later Earl of Clanbrassil. An old source describes Lady Anne as "very handsome, and witty . . . a woman extraordinary in knowledge, virtue, and piety." A similar background, which must have been a studio property, appears in Van Dyck's portrait of the Countess's aunt and in one of the first Duke of Hamilton.

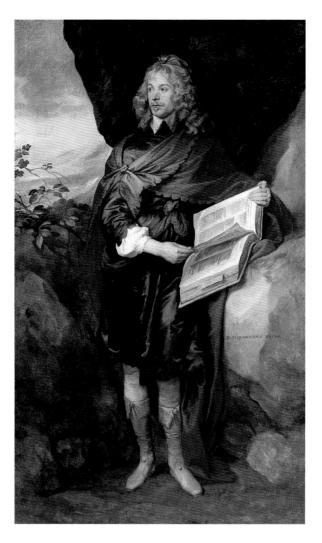

Van Dyck Sir John Suckling Oil on canvas, 85¹/₄ x 51¹/₄ (216.5 x 130.2) Painted between 1632 and 1641, 18.1.44

In his own day John Suckling (1609–1642) was famous not only as a lyric poet, but also as a wit, gambler, soldier, and gallant who conducted himself with an extravagance remarkable even at the court of Charles I. Implicated in a plot to put Charles in command of the army, which was then loyal to the Roundheads, he fled in 1641 to Paris, where he later reputedly committed suicide. In this portrait Suckling, represented in theatrical dress, holds a volume of Shakespeare opened to *Hamlet*, no doubt in tribute to the writer who strongly influenced his own work and to the play from which he often borrowed language and ideas.

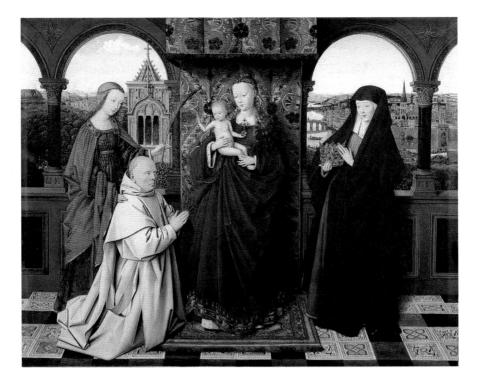

Jan van Eyck and Workshop Active 1422–1441

Van Eyck, born probably at Maaseyck in the province of Limburg, is first recorded in 1422 working at The Hague for the Count of Holland. In 1425 he was named court painter to Philip the Good, Duke of Burgundy, for whom he also undertook frequent diplomatic missions. Most of his datable paintings were executed in Bruges in the 1430s.

Virgin and Child, with Saints and Donor Oil on panel, 185/8 x 241/8 (47.3 x 61.3) Painted probably in the early 1440s. 54.1.161

The Virgin and Child are flanked by St. Barbara, with her attribute, the tower in which she was imprisoned, rising behind her, and St. Elizabeth of Hungary, who gave up the crown she carries to become a nun. The kneeling Carthusian monk is Jan Vos, prior of the Charterhouse of Genadedal, near Bruges, who commissioned the work. Many attempts have been made to identify the walled town at right, but despite the remarkably vivid details the view appears to be imaginary. Most modern scholars consider this one of van Eyck's last paintings, begun by him in 1441 but completed in his shop.

Jean-Honoré Fragonard 1732–1806

Brought to Paris at an early age, Fragonard worked briefly with Chardin and then with Boucher. In 1752 he won the Prix de Rome, and in 1756 he began five years of study in Italy. After his return he was much in demand at the court of Louis XV for his blithe pastoral scenes, landscapes, and decorative paintings. Fragonard held various public offices during the Revolution but lost them all under the Directory. He died in poverty.

The Progress of Love

The first four panels of this series—The Pursuit, The Meeting, The Lover Crowned, and Love Letters—were commissioned by Madame du Barry for a new dining pavilion in the garden of her château at Louveciennes, overlooking the Seine west of Paris. Begun probably in 1771, they were seen at Louveciennes in 1772 and described in the press as not vet finished, but subsequently they were rejected, possibly because their style seemed old-fashioned in a building designed in the new classicizing manner. Joseph-Marie Vien provided replacements in the "antique" taste, and Fragonard retained his paintings until, in 1790, he retired for a year to his native Grasse. There he installed the four original panels in the main salon of his cousin Maubert's house and, to complete the decoration, painted two more large panels, four overdoors with Cupids, and four slender panels with hollyhocks. Though the full meaning of the individual panels and of the series as a whole has yet to be satisfactorily explained, the Frick canvases, with their grand scale and elaborate compositions, are major examples of Fragonard's art and rank among the outstanding achievements of French decorative painting of the eighteenth century.

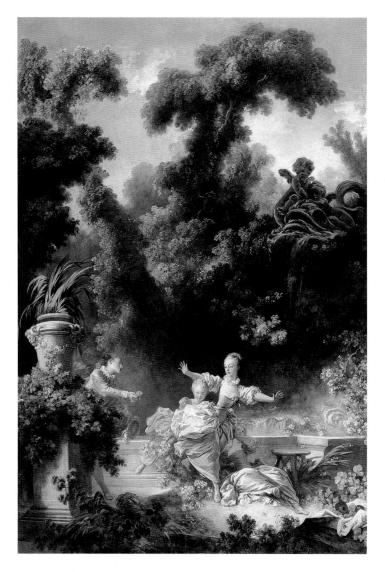

The Pursuit Oil on canvas, 125¹/8 x 847/8 (317.8 x 215.5) Signed: *fragonard* Painted between 1771 and 1773. 15.1.45

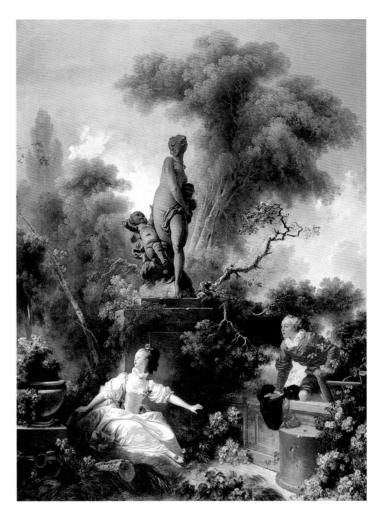

The Meeting Oil on canvas, 125 x 96 (317.5 x 243.8) Signed: *fragonard* Painted between 1771 and 1773. 15.1.46

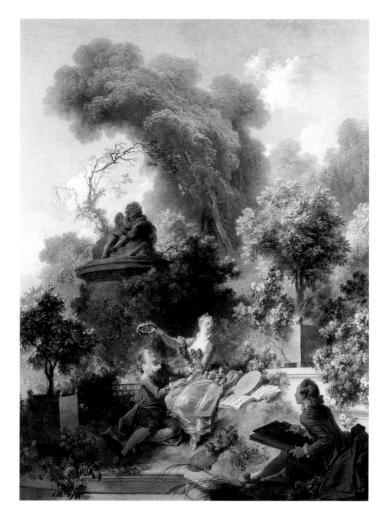

The Lover Crowned Oil on canvas, 125¹/8 x 95³/4 (317.8 x 243.2) Signed: *fragonard* Painted between 1771 and 1773. 15.1.48

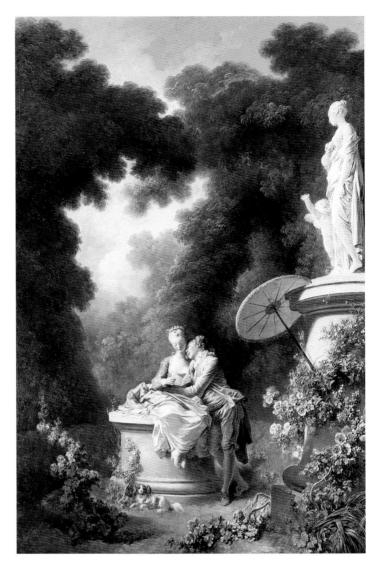

Love Letters Oil on canvas, 1247/8 x 853/8 (317.1 x 216.8) Signed: *fragonard* Painted between 1771 and 1773. 15.1.47

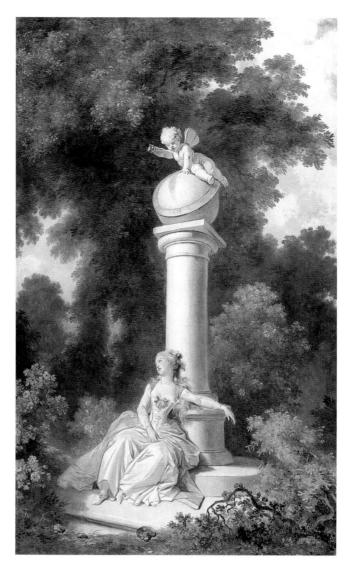

Reverie

Oil on canvas, 125¹/8 x 77⁵/8 (317.8 x 197.1) Painted 1790–91. 15.1.49

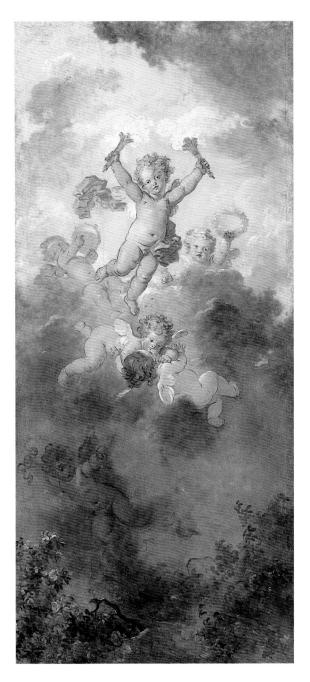

Love Triumphant Oil on canvas, 125 x 56¹/2 (317.5 x 143.5) Painted 1790–91. 15.1.50

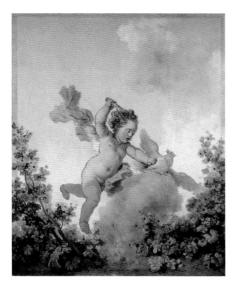

Love the Avenger Oil on canvas, 593/8 x 503/8 (150.8 x 127.9) Painted 1790–91. 15.1.51

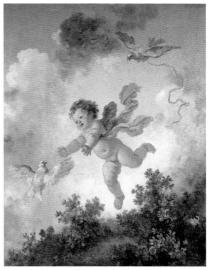

Love Pursuing a Dove Oil on canvas, 595/8 x 473/4 (151.4 x 121.4) Painted 1790–91. 15.1.52

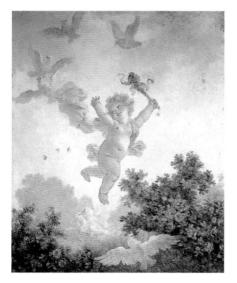

Love the Jester Oil on canvas, 593/8 x 503/8 (150.8 x 127.9) Painted 1790–91. 15.1.53

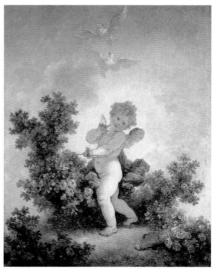

Love the Sentinel Oil on canvas, 575/8 x 471/2 (146.3 x 120.6) Painted 1790–91. 15.1.54

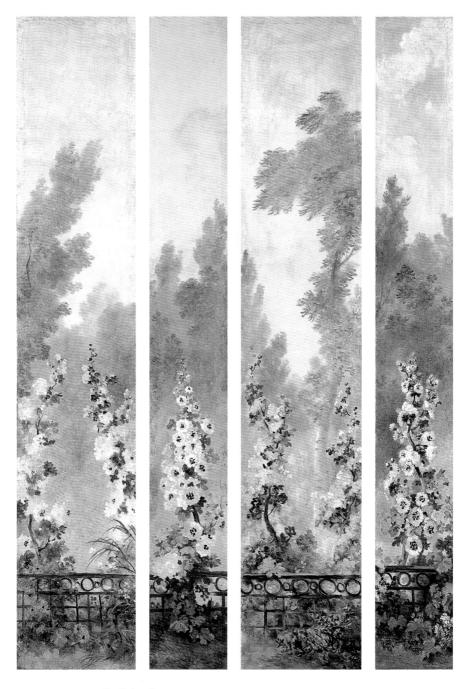

Hollyhocks

Oil on canvas, nos. 55A, C, 125¹/4 x 25 (318.2 x 63.5); nos. 55B, D, 125¹/2 x 16³/8 (318.8 x 41.6) Painted 1790–91. 15.1.55 A–D

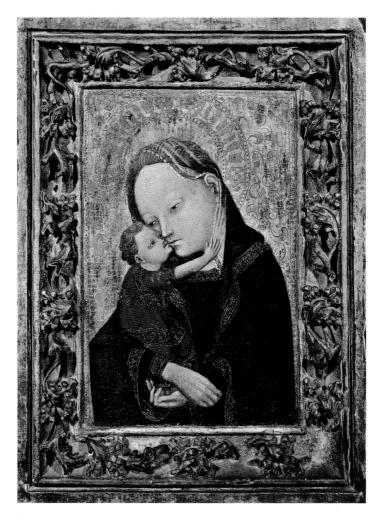

French, Probably Burgundian About 1390–1400

Virgin and Child

Oil and tempera on panel, 85/8 x 55/8 (21.9 x 14.3); with frame, 121/8 x 91/4 (30.8 x 23.5). Date unknown. 27.1.57

The national origin of this panel is uncertain, as are the origins of many late Gothic works. The artist appears to have been familiar with contemporary Italian painting as well as with the art of France and Flanders. The tender sentiment, rich coloring, and decorative patterning are associated with many European centers, but the style comes closest to Burgundian painting of the late fourteenth century. The panel and its frame carved with spiraling vines are made from a single piece of wood.

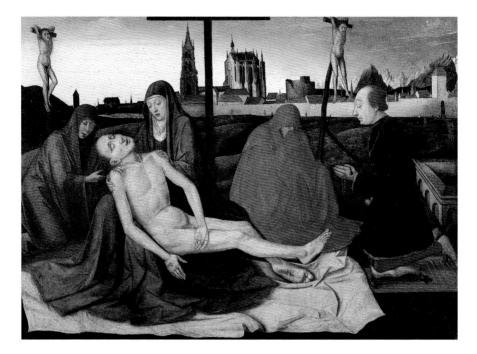

French, Probably South of France Fifteenth Century

Pietà with Donor

Tempera or mixed technique on panel, $155/8 \ge 22$ (39.7 ≤ 55.8) Date unknown. 07.1.56

The Pietà, a representation of the Virgin supporting the dead Christ in a pose that poignantly recalls the image of her holding the Child, is a motif that first appears in Germanic art of the fourteenth century. Here the figures are set in a landscape which includes Christ's sepulcher at right behind the unidentified donor, a Gothic city representing Jerusalem, and distant snowcapped mountains. This panel, once attributed to Antonello da Messina, now is believed to have been painted in Savoy or Provence during the middle or final third of the fifteenth century. It is an enlarged copy with variations of a *Pietà* without donor also in The Frick Collection (see Konrad Witz, Circle of, p. 167).

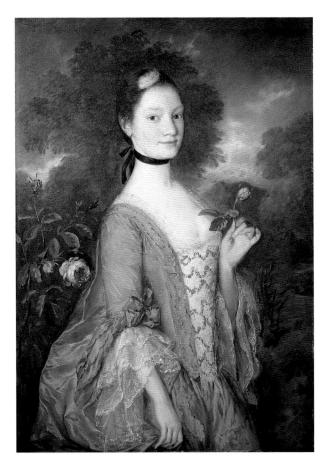

Thomas Gainsborough 1727–1788

Gainsborough left his native Suffolk in 1740 for London, where he worked with the French engraver Gravelot and probably with Francis Hayman. He moved to Ipswich about 1752 and to the fashionable resort of Bath in 1759, returning to London only in 1774. Best known for his portraits, he also painted numerous landscapes.

Sarah, Lady Innes Oil on canvas, 40 x 285/8 (101.6 x 72.7) Painted about 1757. 14.1.58

According to family tradition the sitter was Sarah, daughter and heiress of Thomas Hodges of Ipswich. She married Sir William Innes, captain of the Second Light Dragoons, and died in 1770. This portrait, painted early in Gainsborough's career, is still somewhat stiff in its mannered pose, but the diaphanous fabrics and softly brushed landscape presage the artist's mature style.

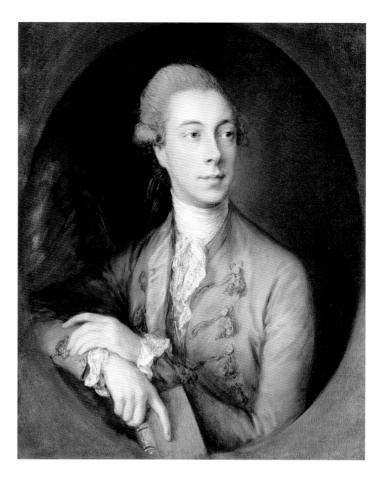

Gainsborough Richard Paul Jodrell Oil on canvas, 30¹/₄ x 25¹/₈ (76.8 x 63.8) Painted about 1774. 46.1.154

Richard Jodrell (1745–1831) was an antiquarian, philologist, and dramatist, a Member of Parliament, and a friend of Dr. Johnson. To judge from his apparent age he must have posed for this portrait toward the end of Gainsborough's Bath period or shortly after the artist had moved to London. With its technique of transparent glazes of color, the painting exhibits a quality that Gainsborough's great rival Sir Joshua Reynolds singled out for praise: "the lightness of effect which is so eminent a beauty in his work."

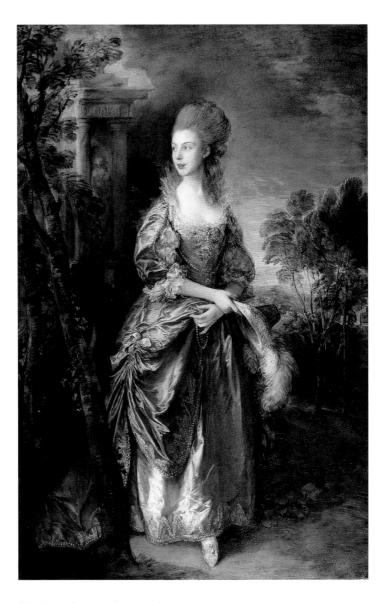

Gainsborough

The Hon. Frances Duncombe Oil on canvas, 92¹/₄ x 61¹/₈ (234.3 x 155.2) Painted about 1777. 11.1.61

Frances (1757–1827), daughter of Anthony Duncombe, Baron of Downton, Wiltshire, was married in 1778 to John Bowater of London. Gainsborough also painted a half-length portrait of her dated 1773. The Frick canvas testifies to the artist's admiration for Van Dyck, not only in its elegant proportions, graceful pose, and Arcadian setting, but even in the costume, which recalls fashions of the seventeenth century.

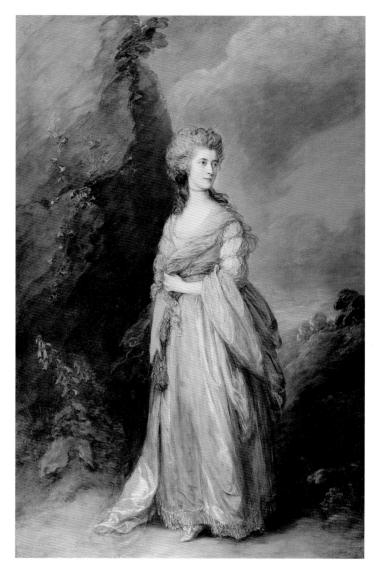

Gainsborough Mrs. Peter William Baker Oil on canvas, 895/8 x 593/4 (227.6 x 151.8) Signed and dated: Thos. Gainsborough / 1781. 17.1.59

Jane (d. 1816), daughter of James Clitherow of Boston House, Middlesex, married Peter Baker of Ranston, Dorsetshire, in 1781—the year of this portrait. The windswept natural setting, which recalls the landscape paintings of Gainsborough's late years, invests this classically simple composition with a feeling of movement and drama.

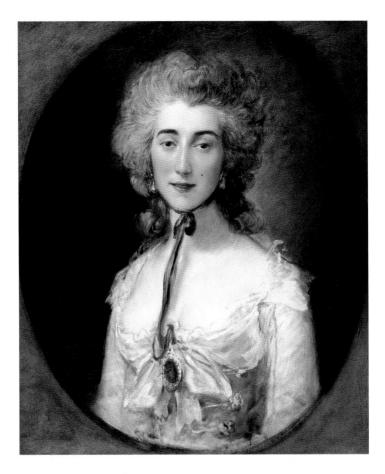

Gainsborough Oil on canvas, 30¹/8 x 25 (76.5 x 63.5) Painted probably in 1782. 46.1.153

Grace Dalrymple (c. 1754–1823), daughter of an Edinburgh barrister, married Sir John Elliott in 1771 but was divorced by him five years later. A remarkably tall and striking woman, she gained considerable notoriety through her liaisons with such prominent figures as the Prince of Wales, who may have commissioned this portrait, and Philippe Égalité, Duc d'Orléans, whose mistress she was at the time of the French Revolution. When the portrait was exhibited at the Royal Academy in 1782, it evoked much comment; the hair was criticized, and the subject's high coloring and expression were said to denote her calling.

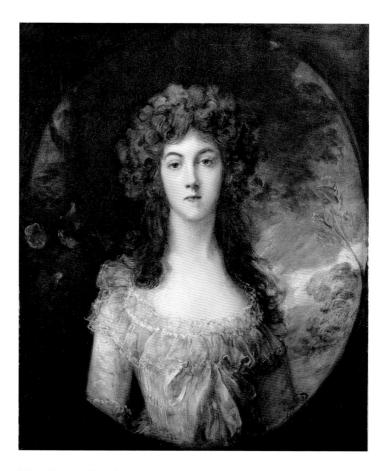

Gainsborough

Mrs. Charles Hatchett Oil on canvas, 29³/4 x 24⁵/8 (75.5 x 62.5) Painted perhaps in 1786. 03.1.60

Elizabeth Collick (c. 1766–1837), a gifted pianist and pupil of Clementi, married Charles Hatchett of London, discoverer of the metallic element columbium (now called niobium) and friend of many leading intellectuals of his day. The Hatchetts appear to have been on close terms with Gainsborough, who shared their love of music.

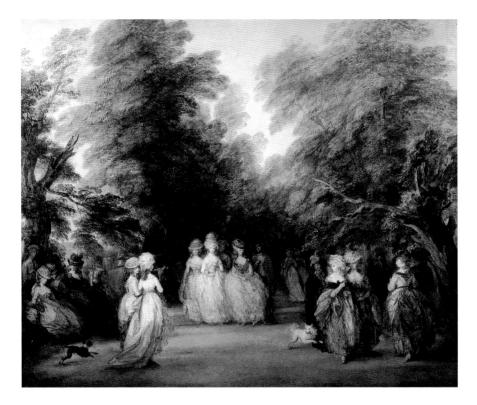

Gainsborough The Mall in St. James's Park Oil on canvas, 47¹/₂ x 57⁷/₈ (120.6 x 147)

Painted probably in 1783. 16.1.62

St. James's Park was near Gainsborough's London residence, Schomberg House, in Pall Mall. *The Mall*, with its carefully arranged figure groups combined in a landscape setting, is unusual among the artist's later works and recalls, as several contemporary critics remarked, the *fêtes galantes* of Watteau. The feathery foliage and rhythmic design led one observer to describe the painting as "all aflutter, like a lady's fan." Another reported that the artist composed the painting partly from dolls and a model of the setting. Attempts to identify the ladies in the central group as the daughters of George III and the background figure under the trees at right as the artist himself are attractive but unsubstantiated.

Gentile da Fabriano c. 1370-1427

Gentile was born in Fabriano, near Urbino, but is first recorded in 1408 in Venice. He worked there, in Brescia, and probably in other North Italian towns before moving about 1420 to Tuscany, where for the next few years he received important commissions from churches and great families of Siena, Florence, and Orvieto. By 1427 he had left for Rome to paint a series of frescoes, now lost, in St. John Lateran.

Madonna and Child, with Saints Lawrence and Julian

Tempera on panel, 35³/₄ x 18¹/₂ (90.8 x 47) Signed, on the frame: *gentili[s?]* [*de?*] Painted about 1423–25. 66.1.167

This small but richly painted altarpiece was designed perhaps for some private family chapel. It must be close in date to Gentile's best-known work, the *Adoration of the Magi* of 1423, commissioned by the Strozzi family of Florence and now in the Uffizi. Like the *Adoration*, this panel, with its elegantly ornamented surface of glittering gold leaf and brilliant color, perpetuates late Gothic traditions, most obviously in the gentle, graceful figures of the Madonna and Child. The adoring saints, however, seem more advanced than work of the same date by Gentile's Florentine contemporaries; the portrait-like heads and solidly modeled bodies are strikingly natural and eloquent. St. Lawrence, the third-century Roman deacon, kneels at left beside the grid on which he was burned alive. At right, wearing knightly robes and sword, is St. Julian the Hospitaler, who built a refuge for travelers.

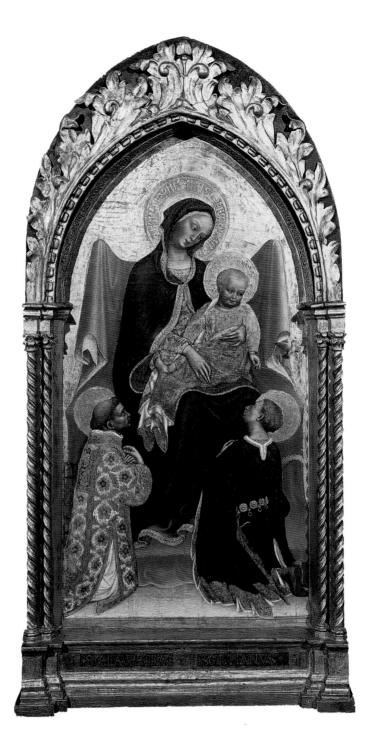

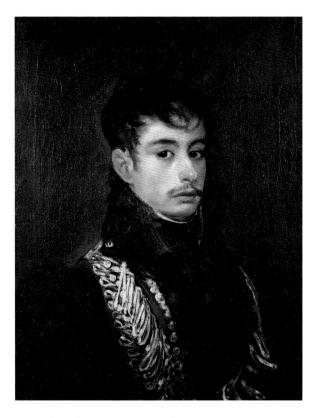

Francisco de Goya y Lucientes 1746–1828

Born in Fuendetodos, Goya served his apprenticeship in nearby Saragossa and then studied with Francisco Bayeu in Madrid. He was in Italy in 1771, worked in Saragossa the following year, and in 1774 became a designer for the Royal Tapestry Factory. Appointed court painter to Charles III in 1786, he continued in that post under Charles IV and Ferdinand VII. In addition to portraits, Goya painted historical, religious, and genre subjects, bitter satires, and demonological fantasies; he also was a brilliant graphic artist. In 1824, out of favor with the court, he left Spain and settled in Bordeaux, where he died.

An Officer (Conde de Teba?) Oil on canvas, 247/8 x 191/4 (63.2 x 48.9) Date unknown. 14.1.64

The intense and wary young officer who posed for this portrait has yet to be convincingly identified, though several candidates have been put forward. The most likely is Don Francisco Leandro de Viana, Conde de Teba, who was active in colonial affairs and whose wife had vast holdings in Mexico.

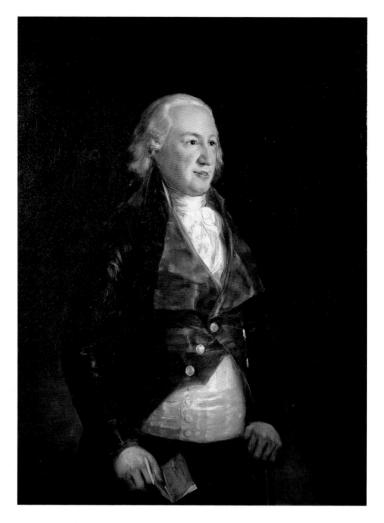

Goya Don Pedro, Duque de Osuna Oil on canvas, 44¹/2 x 32³/4 (113 x 83.2) Signed: *Por Goya*. Painted probably in the 1790s. 43.1.151

Don Pedro de Alcántara Téllez-Girón y Pacheco (1755–1807), ninth Duque de Osuna, was one of Spain's wealthiest and most talented noblemen during the reigns of Charles III and Charles IV. After the royal court he and his wife were Goya's most faithful patrons, commissioning more than twenty-four works, including portraits, religious subjects, and a famous set of decorative canvases for their country palace outside Madrid.

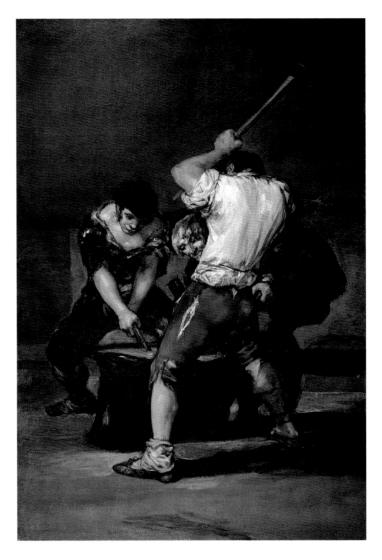

Goya

The Forge

Oil on canvas, 71¹/2 x 49¹/4 (181.6 x 125.1) Painted about 1815–20. 14.1.65

The composition of this canvas derives from traditional depictions of the forge of Vulcan, the metalworker of the Olympian gods. Goya, however, translates the theme into contemporary language, using sturdy laborers in working clothes as a subject suitable for monumental treatment. The rough, vigorous application of paint and somber coloring heighten the power and intensity of the figures and their actions.

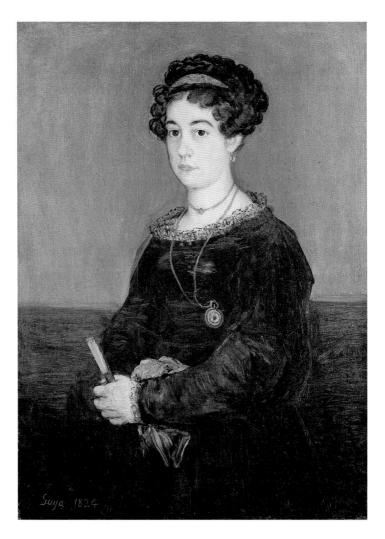

Goya Doña María Martínez de Puga Oil on canvas, 31½ x 23 (80 x 58.4) Signed and dated: *Goya 1824*. 14.1.63

> The almost monochromatic palette and broad brushwork employed here are characteristic of Goya's last portraits. The date of the canvas indicates that it could have been painted in Madrid shortly before the artist left Spain or in Paris or Bordeaux later that year. Of the various identities that have been proposed for the sitter none has been verified, and even her presumed name, supplied by a previous owner, is in question.

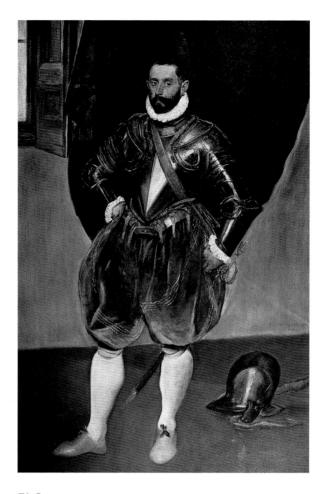

El Greco 1541-1614

Domenikos Theotokopoulos, called El Greco, was born in the Venetian dependency of Crete. As a youth he traveled to Venice, where he reputedly studied with Titian. He was in Rome in 1570 and by 1577 had settled in Toledo, where he spent his remaining years. His work consists chiefly of religious subjects and portraits.

Vincenzo Anastagi

Oil on canvas, 74 x 497/8 (188 x 126.7). Signed in Greek characters. Painted about 1571–76. 13.1.68

Vincenzo Anastagi (c. 1531–1586) joined the Knights of Malta in 1563 and was a leader in the heroic defense of that island during the massive Turkish siege of 1565. He later became sergeant major of Castel Sant'Angelo in Rome. This portrait, Venetian in conception but already characteristically intense and spirited in style, probably dates from El Greco's last years in Italy.

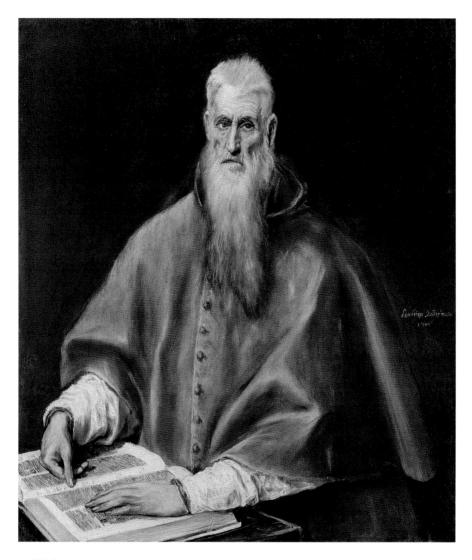

El Greco St. Jerome

Oil on canvas, $43\frac{1}{2} \times 37\frac{1}{2} (110.5 \times 95.3)$ Signed in Greek characters. Painted about 1590–1600 05.1.67

St. Jerome (c. 342–420), one of the four great Doctors of the Western Church, is venerated for his ascetic piety and for his monumental translation of the Greek Bible into Latin, known as the Vulgate, represented here by the large volume on which he rests his hands. Following an old convention, the artist depicts him in the robes of a cardinal. This composition proved popular and was produced in at least four versions by El Greco and his shop.

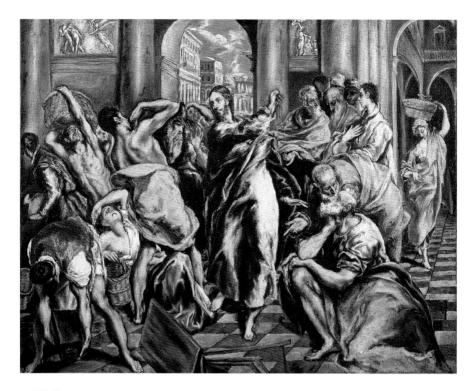

El Greco Purification of the Temple Oil on canvas, 16¹/2 x 20⁵/8 (41.9 x 52.4) Painted about 1600. 09.1.66

> The subject of Christ driving the traders and moneychangers from the Temple assumed special significance during the Counter Reformation as a symbolic reference to the purification of the Church. The theme absorbed El Greco throughout his career, as is demonstrated by the many versions of this composition that issued from his shop. The Frick canvas, one of the later examples, is small in size but generates remarkable dramatic intensity through its explosive movement and cold but brilliant coloring.

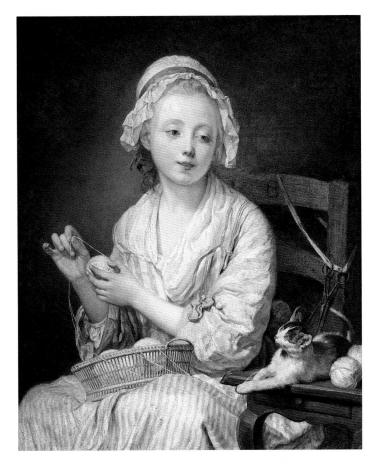

Jean-Baptiste Greuze 1725–1805

Greuze left his native Burgundy for Paris about 1750 and studied at the Academy. He first exhibited at the Salon in 1755, and later that year he began a long sojourn in Italy. He was made a full Academy member in 1769. Greuze's anecdotal, often moralizing genre scenes and his incisive portraits won him great acclaim among the public, such art critics as Denis Diderot, and discerning collectors, including the Empress Catherine II of Russia.

The Wool Winder Oil on canvas, 29³/8 x 24¹/8 (74.6 x 61.3) Painted probably in 1759. 43.1.148

Like many of Greuze's early works, *The Wool Winder* is related to Chardin's genre pictures of the 1730s, but Greuze's scenes are usually, as here, more whimsical and psychologically acute. The letter *B* carved into the top rail of the chair suggests that the subject may have been a younger sister of the artist's wife, Anne-Gabrielle Babuti.

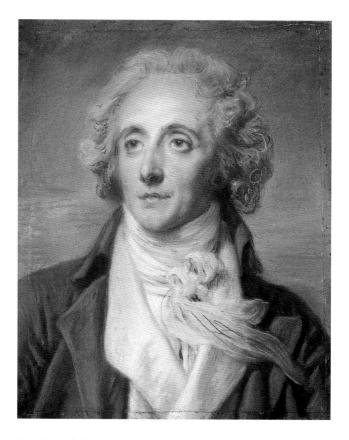

Greuze Baptiste Aîné

Pastel on cream paper, 16¹/2 x 13¹/4 (41.9 x 33.7) Affixed at time of execution to a larger sheet, 17³/4 x 14³/4 (45.1 x 37.5) mounted on stretchers Drawn about 1799. Purchased by The Frick Collection with funds bequeathed in memory of Suzanne and Denise Falk 96.3.126

Nicolas-Pierre-Baptiste-Anselme (1761–1835), called Baptiste *aîné* (for fils *aîné*, or "elder son"), established himself as an actor and singer in Rouen in the 1780s. He joined the company of the Théâtre de la République and the Comédie-Française, where he remained until his retirement in 1828. He performed in works by Corneille, Molière, and Racine, as well as those by his contemporaries Beaumarchais and Voltaire. Besides being renowned for his professional assiduity, Baptiste *aîné* also, as one colleague recalled, "made himself loved by everyone through his proverbial affability." This portrait and the pendant of his wife might have been commissioned as a result of his entry into the Comédie-Française in 1799.

Greuze Madame Baptiste Aîné

Pastel on cream paper, 18 x 145/8 (45.6 x 36.6) Drawn about 1799. Purchased by The Frick Collection with funds bequeathed in memory of Suzanne and Denise Falk 96.3.127

Far less is known about Madame Baptiste *aîné* than about her celebrated husband. Née Anne-Françoise Gourville, she married Baptiste in Rouen at some point between 1783 and 1785. Their union seems to have been a lasting one of deep and mutual affection. By the time the couple was performing at the Théâtre de la République, she was being assigned roles of increasingly lesser importance; one critic wrote, "She had a terrible fault, which consisted of not allowing to be heard a single verse that she delivered."

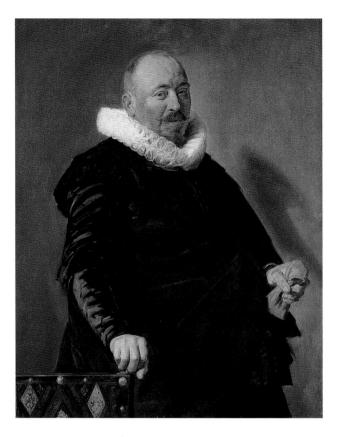

Frans Hals 1581/85–1666

Hals probably was born in Antwerp, but by 1591 his family had moved to Haarlem, where he is believed to have studied with Carel van Mander. He joined the painters' guild of Haarlem in 1610 and worked in that city until his death, painting chiefly portraits, including several large group portraits of militia companies and the regents of charitable institutions.

Portrait of an Elderly Man Oil on canvas, 45¹/2 x 36 (115.6 x 91.4) Painted about 1627–30. 10.1.69

The subject of this portrait has recently been identified as Cornelis Backer (d. 1655), a burgomaster, who also appears in Hals's group portrait *Assembly of Officers and Subalterns of the Civic Guard of St. Adrian at Haarlem.* The technique of this painting dating from Hals's early maturity is derived in part from Rubens. The thin, fluid handling of the paint, the warm but restricted color scheme, and Backer's animated expression and self-confident air are typical of Hals's major works from those years.

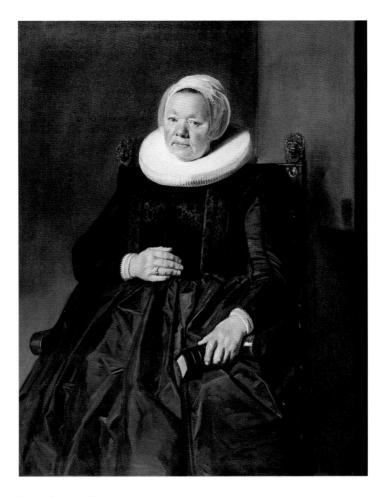

Hals Portrait of a Woman Oil on canvas, 457/8 x 363/4 (116.5 x 93.3) Dated: 1635. 10.1.72

An inscription at upper left gives the age of the unidentified sitter as fifty-six. The portrait records her features with objectivity and with a blunt, vigorous brushwork that seems in itself to reflect her character. Like most of Hals's works, this one employs a plain background well suited to his unpretentious style of portraiture.

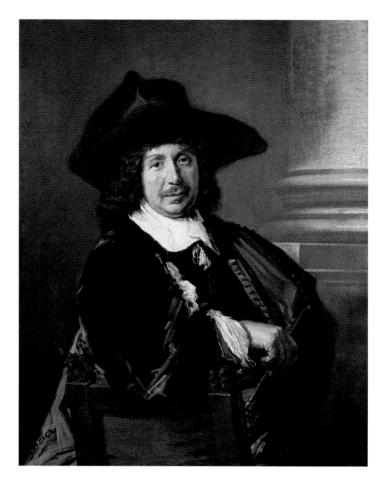

Hals

Portrait of a Painter

Oil on canvas, $39^{1/2} \ge 32^{5/8}$ (100.3 ≥ 82.9) Painted probably in the early 1650s Spurious signature and date: F. H. / 16[5?]—. 06.1.71

This canvas was once considered a self-portrait, but comparison with known likenesses of Hals makes the identification improbable. The painting was altered at some time by the addition of the column at right and by areas of retouching in the hand and parts of the costume. Nevertheless, the strongly modeled head, with its alert, quizzical aspect, is characteristic of Hals's portraiture at its best.

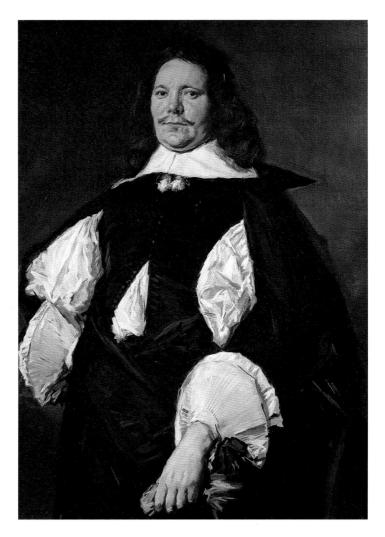

Hals Portrait of a Man Oil on canvas, 44¹/2 x 32¹/4 (113 x 81.9) Signed: FH. Painted probably about 1660. 17.1.70

Once erroneously believed to represent the seventeenth-century Dutch naval hero Michiel de Ruyter, this portrait of an unknown man appears to have been painted when Hals was already well over seventy. By then he had developed the flashing bravura technique—particularly evident in the drapery and gloves—that would later influence Manet.

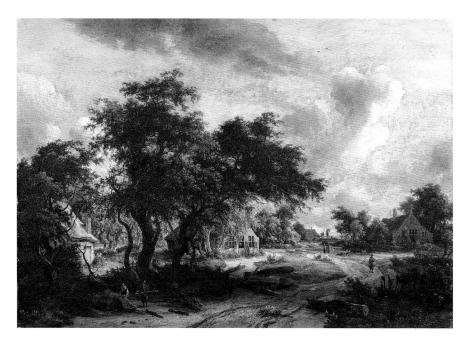

Meyndert Hobbema 1638–1709

In 1657 Hobbema was apprenticed in his native Amsterdam to Jacob van Ruisdael, whose style and subject matter had a profound influence on him. Hobbema painted landscapes prolifically until 1688, when he was appointed municipal assessor of wine-measures. Relatively few works appear to date from his last forty years.

Village among Trees

Oil on oak panel, 30 x 43¹/₂ (76.2 x 110.5) Signed and dated: *m. hobbema / f.*1665. 02.1.73

This panel, painted during Hobbema's most active period, is composed of elements he employed repeatedly throughout his career: large trees with variegated foliage, picturesque cottages, a low sky with wind-swept clouds, and a rutted road that winds into the far distance.

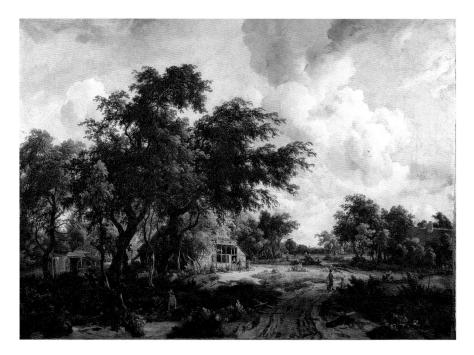

HobbemaVillage with Water Mill among TreesOil on canvas, 371/8 x 511/8 (94.3 x 129.8)Date unknown. Signed: meynd " hobbema. 11.1.74

Comparison of this canvas with the preceding *Village among Trees*, which dates from about the same time, clearly demonstrates that if Hobbema's repertory of motifs observed in nature was limited, he nevertheless invested his paintings with considerable freshness and variety. No other major Dutch landscapist was so economical of design and visual material.

William Hogarth 1697–1764

A lifelong resident of London, Hogarth was apprenticed to an engraver of silver plate at fifteen and later studied drawing with Thornhill. His fame among his contemporaries derived chiefly from the series of moral satires, such as The Rake's Progress and Marriage à la Mode, that he engraved after his own oil paintings. He also produced portraits and was the author of an autobiography and a treatise on aesthetics.

Miss Mary Edwards

Oil on canvas, 49³/₄ x 39⁷/₈ (126.4 x 101.3) Signed and dated: w. HOGARTH 1742. 14.1.75

Mary Edwards (1705–1743), one of the richest women of her time, was married clandestinely to Lord Anne Hamilton, a younger son of the fourth Duke of Hamilton. A few years later, in order to protect her fortune from her extravagant husband, she repudiated the marriage, though this action was tantamount to declaring her infant son illegitimate. Hogarth's straightforward, lively style of portraiture clearly suited the strong personality of his subject.

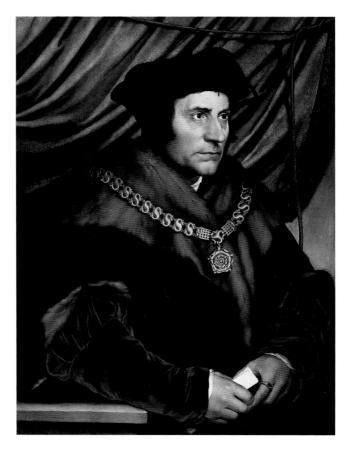

Hans Holbein the Younger 1497/98–1543

Holbein was the son of the Augsburg painter Hans Holbein the Elder, who probably gave him his first training. By 1515 he was working in Basel, where he achieved great success. He lived in England from 1526 to 1528 and four years later returned to settle there, eventually becoming court painter to Henry VIII.

Sir Thomas More

Oil on oak panel, 29¹/2 x 23³/4 (74.9 x 60.3) Dated: M.D.XXVII [1527]. 12.1.77

Thomas More (1477/78–1535), humanist scholar, author, and statesman, served Henry VIII as diplomatic envoy and Privy Councillor prior to his election as speaker of the House of Commons in 1523. In 1529 he succeeded Cardinal Wolsey as Lord Chancellor, but three years later he resigned that office over the issue of Henry's divorce, and subsequently he refused to subscribe to the Act of Supremacy. For this he was convicted of high treason and beheaded. He was canonized in 1935.

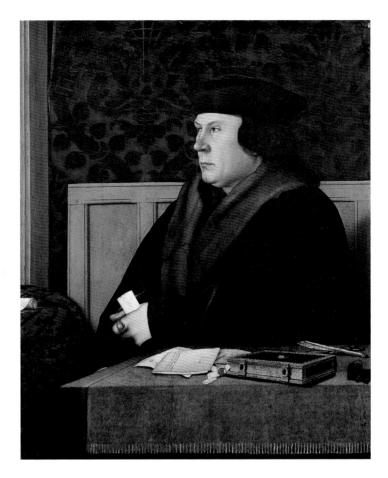

Holbein Thomas Cromwell Oil on oak panel, 307/8 x 253/8 (78.4 x 64.4) Date unknown. 15.1.76

Thomas Cromwell (c.1485–1540) was the son of a London blacksmith and tavern-keeper. He entered Cardinal Wolsey's service in 1514 and held various high offices under Henry VIII, culminating in his appointment as Lord Great Chamberlain in 1539. He was largely responsible for the execution of Thomas More. In 1540 Cromwell fell from Henry's favor and was himself accused of treason and beheaded. Of the several versions of this portrait, the Frick example is considered the best and oldest.

John Hoppner 1758–1810

Hoppner spent his boyhood as a chorister at St. James's Palace before entering the Royal Academy in 1775. He first exhibited at the Academy in 1780, and in 1795 he became full Academician. He enjoyed great popularity as a portraitist, serving in that capacity to the Prince of Wales (later George IV).

The Hon. Lucy Byng

Oil on canvas, 30¹/8 x 25 (76.5 x 63.5) Date unknown. 99.1.79

Some uncertainty exists over the identity of the subject, who may have been either Lucy Elizabeth Byng (1794–1875), daughter of Vice-Admiral George Byng, sixth Viscount Torrington, or another Lucy Elizabeth Byng, daughter of George Byng, fourth Viscount Torrington. Hoppner's feathery brushwork did not vary sufficiently over the years to permit a dating on stylistic grounds.

Hoppner The

The Ladies Sarah and Catherine Bligh Oil on canvas, $511/8 \ge 403/8 (129.8 \ge 102.5)$ Painted about 1790. 15.1.80

Lady Sarah Bligh (1772–1797), kneeling, and her sister Lady Catherine (1774–1812) were the youngest children of John Bligh, third Earl of Darnley. The open water with distant sails in the background of this portrait may represent the Thames at Gravesend as seen from the Bligh estate of Cobham Park.

Jean-Auguste-Dominique Ingres 1780–1867

Born in Montauban, Ingres studied first in nearby Toulouse and then with David in Paris. He won the Prix de Rome in 1801 and was in Italy from 1806 until 1824. He spent the following decade in Paris, where he received official honors and attracted many pupils, then returned to Rome for seven years as Director of the French Academy. His final years were spent in Paris.

Comtesse d'Haussonville

Oil on canvas, 517/8 x 361/4 (131.8 x 92) Signed and dated: INGRES./1845. 27.1.81

Louise, Princesse de Broglie (1818–1882), married at the age of eighteen. Her husband was a diplomat, writer, and member of the French Academy, and she herself published a number of books, including a life of Byron. This portrait, begun in 1842, was the fruit of several false starts and a great many preparatory drawings, one of which is in The Frick Collection. According to a letter written by the artist, the finished work "aroused a storm of approval."

Jacques de Lajoue, Attributed to 1686/87-1761

The son of an architect, Lajoue was born in Paris. By 1721 he was an associate of the Academy, where he exhibited until 1753. A painter of landscapes, seascapes, interiors, and animal studies, he assisted in the decoration of many châteaux and palaces.

Seven Decorative Panels

Oil on canvas: Nos. 82A, C, E, G, 585/8 x 211/2 (148.9 x 54.6); Nos. 82B, D, F, 585/8 x 177/8 (148.9 x 45.4). Painted perhaps in the 1730s. 16.1.82 A-G

These panels probably were commissioned to be set in the walls of a room and may originally have formed part of a larger suite representing the twelve months. They are attributed to Lajoue on the basis of their resemblance to his engraved designs and decorative paintings, which employ similarly asymmetric compositions and a profusion of shells, canopies, trellises, and consoles.

Studio of Georges de La Tour 1593-1652

Most of La Tour's life was spent in his native Lorraine, but his style, which appears to have been influenced by Caravaggio or his Dutch followers, suggests that he may have traveled abroad. A document of 1639 refers to him as "Peintre ordinaire du Roy," and he also worked for Lorraine's ducal court. He and his family died in an epidemic at Lunéville.

The Education of the Virgin

Oil on canvas, 33 x 39¹/2 (83.8 x 100.4) Signed: *de la Tour f*. Painted about 1650. 48.1.155

La Tour's striking use of light transfigures simple genre motifs and lends his scenes an air of mysterious significance. The subject of the education of the Virgin, who reads from a Bible held by her mother, St. Anne, first appears in fifteenth-century illuminated Books of Hours. Paintings closely similar to this one exist in several collections. This version has also been attributed to La Tour's son Étienne.

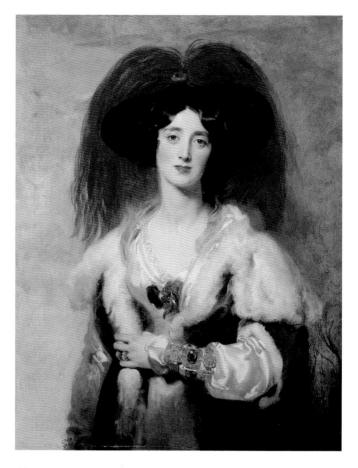

Sir Thomas Lawrence 1769–1830

Lawrence, born in Bristol, was appointed Painter to the King when only twenty-two. He entered the Royal Academy two years later and in 1820 became its president. His portraits earned him a reputation on the Continent unequaled by any earlier British painter.

Julia, Lady Peel

Oil on canvas, 35³/₄ x 27⁷/₈ (90.8 x 70.8) Painted in 1827. 04.1.83

Julia Floyd (1795–1859) was married in 1820 to the British statesman Sir Robert Peel, who twice served as Prime Minister and was an avid patron of Lawrence. The Frick portrait apparently was inspired by Rubens's painting of Susanna Fourment known as the *Chapeau de paille*, which Peel had acquired in 1823. When Lawrence's *Lady Peel* was first exhibited in 1827, a critic proclaimed it among "the highest achievements of modern art."

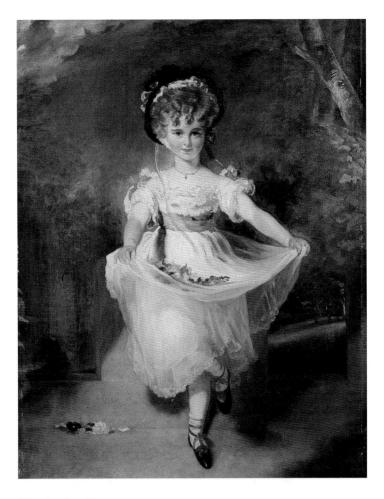

Lawrence Miss Louisa Murray

Oil on canvas, 36¹/2 x 28⁷/8 (92.7 x 73.3) Painted probably after 1827. 16.1.84

Louisa Georgina Murray (1822–1891) was the natural daughter of Gen. The Rt. Hon. Sir George Murray, a soldier and administrator. Of the several versions of Lawrence's portrait of her, that in the Iveagh Bequest at Kenwood, London, is considered the original. The Frick canvas probably is a studio copy.

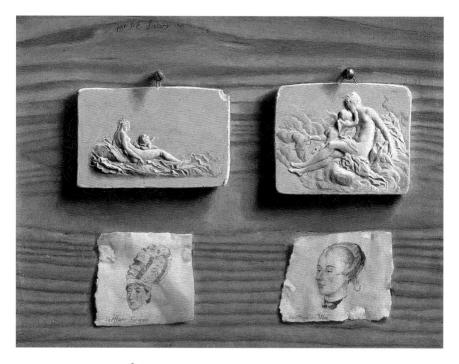

Jean-Étienne Liotard 1702–1789

Born in Geneva to French Huguenot parents, Liotard trained as a miniaturist in enamel. During his lifetime he lived in France, Italy, and Turkey, enjoying great success as an itinerant portrait artist in The Hague, Karlsruhe, London, Paris, Venice, and Vienna, as well as his native Geneva.

Trompe l'Oeil

Oil on silk transferred to canvas, 93/8 x 123/4 (23.3 x 32.3) Signed and dated: *par J. E. Liotard* 1771 Bequeathed by Lore Heinemann in memory of her husband, Dr. Rudolph J. Heinemann. 97.1.182

Only a few of Liotard's still lifes were specifically described by the artist as *deceptio visus*, or "trompe l'oeil." In this painting, against the background of a pine panel, two plaster reliefs—reclining nudes with Cupid—are depicted hanging by a cord from screws. Below them are two crumpled drawings with irregular edges affixed to the pine support with red sealing wax. The sculptures were most likely based on paintings by Boucher, and the drawings are portraits of a turbaned man on the left and a woman from Ulm, in southern Germany, on the right. These images seem to allude to various stages in the artist's life, passed in Paris, Constantinople, and Germany.

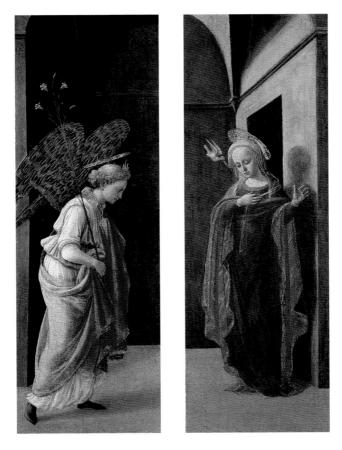

Fra Filippo Lippi c. 1406–1469

Florentine by birth, Fra Filippo took vows of a Carmelite monk at about fifteen. He was in Padua in 1434, but in 1437 he returned to Florence, where he was employed by the Medici and other prominent families. He spent his last two years executing frescoes in the Cathedral at Spoleto.

The Annunciation

Tempera on poplar panels: left panel, 25¼ x 97/8 (63.8 x 25.1); right panel, 25¼ x 10 (63.8 x 25.4) Painted about 1440. 24.1.85

The subject of the Annunciation was exceedingly popular in Florentine art of the mid-fifteenth century, and Fra Filippo depicted it often. The lily carried by the angel Gabriel in such scenes symbolizes the Virgin's purity, while the dove indicates the angel's words to her, "The Holy Ghost shall come upon thee." The two Frick panels, now framed together, probably originally formed the wings of a small altarpiece of which the central panel has been lost.

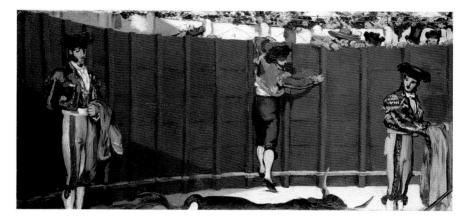

Édouard Manet 1832–1883

Born into a prosperous Parisian household, Manet studied with Couture. He first exhibited at the Salon in 1861, but two years later he showed at the Salon des Refusés, where his work was received with the ridicule that it provoked throughout most of his career. Official recognition came to him only in the year before his death, when he was awarded the Legion of Honor.

The Bullfight

Oil on canvas, 187/8 x 427/8 (47.9 x 108.9) Signed: M. Painted in 1864. 14.1.86

The Bullfight originally formed a section from the upper right-hand side of a painting Manet exhibited in the Salon of 1864 under the title *An Incident in the Bullring*. After the Salon, possibly because the picture was so scathingly reviewed, the artist cut out two separate compositions from the canvas and reworked them, discarding a narrow middle strip and a piece at upper left. The lower, larger section, now known as *The Dead Toreador*, is in the National Gallery of Art, Washington. Such scenes attest to Manet's enthusiasm both for Spain and for the art of Velázquez and Goya.

Jacobus Hendrikus Maris 1837–1899

Maris, born and trained in The Hague, spent the late 1860s in Paris, where he was influenced by the Barbizon landscapists. After his return to Holland in 1871 he became a leading figure in The Hague school of painting, together with his brothers Matthijs and Willem.

The Bridge

Oil on canvas, 44³/8 x 54³/8 (112.7 x 138.1) Signed: *J.Maris*. Painted in 1885. 14.1.87

The site depicted, said to be near Rijswijk on the outskirts of The Hague, was the subject of several related works by Maris, some of them perhaps preparatory studies for this painting. An impression of Maris's own etching of *The Bridge*, with the detail simplified and the composition reversed, also is in The Frick Collection.

Anton Mauve 1838–1888

Mauve studied in his native Zaandam, but the formative influence on his style was that of the Maris brothers. After establishing a reputation in Amsterdam, he joined the group of prominent Dutch artists working at The Hague. He won many prizes at international exhibitions and was highly esteemed in both Europe and America.

Early Morning Ploughing

Oil on canvas, 16³/4 x 22¹/2 (42.5 x 57.2) Signed: *A.Mauve p.* Date unknown. 77.1.170

The artists of The Hague school resembled the Barbizon painters in their reaction against academic art and in their belief that nature and the common man provided the ideal subject matter. But their landscapes usually are distinguished from the more warmly colored works of their French contemporaries by a pervasive silvery gray atmosphere, so characteristic of the Dutch climate. Mauve's young cousin van Gogh, who studied with him, was much influenced in his early period by such muted scenes of peasant life as *Early Morning Ploughing*.

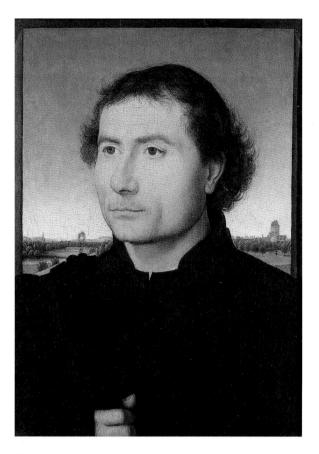

Hans Memling c. 1440–1494

Born at Seligenstadt, near Frankfurt, Memling spent much of his life in Bruges, where he was recorded as a new citizen in 1465. Two years later he entered the Bruges painters' guild, and documents show that he became one of the city's more prosperous residents. In addition to portraits, Memling painted many religious subjects.

Portrait of a Man

Oil on oak panel, 13¹/8 x 9¹/8 (33.5 x 23.2) Date unknown. 68.1.169

Though panels such as this often served as covers or wings for small private altarpieces, it seems probable that the Frick example, like many others dating from the second half of the fifteenth century, was commissioned as an independent painting. Memling was one of the most admired portraitists of his day, in Italy as well as in northern Europe. His popularity was due not only to his great skill in capturing physical likenesses but also to his even rarer gift for conveying the intellectual and spiritual character of his subjects.

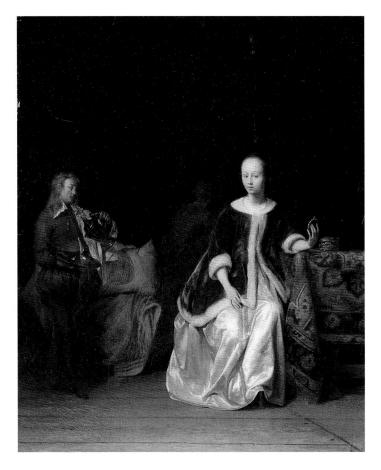

Gabriel Metsu 1629–1667

Metsu was born in Leyden and lived there at least until 1654, but by 1657 he had settled in Amsterdam. He painted genre scenes, small portraits, and religious subjects, and appears to have been influenced by Flemish painters and by his Dutch contemporaries ter Borch, de Hoogh, and Vermeer.

A Lady at Her Toilet

Oil on canvas, 20³/8 x 16⁵/8 (51.7 x 42.2) Signed: *G Metsu*. Painted about 1660. 05.1.88

In Amsterdam, Metsu produced a number of interior scenes inspired by ter Borch in their modest scale, finely painted detail, and richness of handling. As other artists were working in a closely similar vein, the attribution of this canvas is sometimes questioned, despite the apparent signature. Metsu's paintings, only modestly successful during his lifetime, were highly prized by eighteenthcentury collectors.

Jean-François Millet 1814–1875

The son of Norman peasants, Millet studied in Cherbourg and then Paris. His work was shown in several Salons in the 1840s, but it was not until the Winnower of 1848 that he began to exhibit the peasant subjects that made him famous. In 1849 he moved to Barbizon, where he spent most of his remaining years.

Woman Sewing by Lamplight Oil on canvas, 395/8 x 321/4 (100.7 x 81.9) Signed: J. F. Millet. Painted 1870–72. 06.1.89

It has been suggested that Millet's many scenes of peasant women and their families working by lamplight were inspired by his fondness for Latin bucolic poetry, especially certain lines from Virgil's Georgics. Similar treatments by Rembrandt and other Dutch painters must also have influenced his choice of themes. The Frick canvas, finished in Barbizon in 1872, was begun two years earlier in Cherbourg, where Millet had moved his family to escape the invading Prussian armies.

Claude-Oscar Monet 1840–1926

Parisian by birth, Monet spent his youth in Le Havre, where he worked with the painter Boudin. He returned to Paris in 1859 and showed in the Salons of 1865 and 1866. With Bazille, he organized the first Impressionist exhibition in 1874, which included works by Renoir, Pissarro, Boudin, Cézanne, and Degas. Monet painted in many parts of France as well as in Italy, Holland, and England. During his last years he worked chiefly in his gardens at Giverny.

Vétheuil in Winter

Oil on canvas, 27 x 35³/8 (68.6 x 89.9) Signed: *Claude Monet*. Painted in 1879. 42.1.146

In 1878 Monet moved down the Seine from Argenteuil to Vétheuil, a small town which he painted from many different vantage points and in all seasons. The Frick canvas, executed almost entirely in blues and blue-greens with touches of rose tinting the snow and houses, vividly conveys and impression of the intense cold that occurred during the winter of 1879–80.

Jean-Marc Nattier 1685–1766

Nattier, a Parisian, studied at the Academy and was already a portraitist of note by the age of eighteen. In 1717 Peter the Great summoned him to Holland to paint members of the visiting Russian court, and the following year he became a member of the Academy. He exhibited frequently in the Salons and received many commissions from the court of Louis XV.

Elizabeth, Countess of Warwick

Oil on canvas, 32¹/8 x 25³/4 (81.5 x 65.4) Signed and dated: *Nattier/p.x.* 1754. 99.1.90

Elizabeth Hamilton (c. 1720–1800), daughter of a younger son of the Duke of Hamilton, was married in 1742 to Francis Greville, later Earl of Warwick. On hearing of their engagement, Horace Walpole wrote, "She is excessively pretty and sensible, but as diminutive as he." Nattier also painted at least two portraits of her husband. The composition of the Frick canvas, simple and restrained, differs markedly from the opulent and frequently allegorical portraits with which the artist usually is associated.

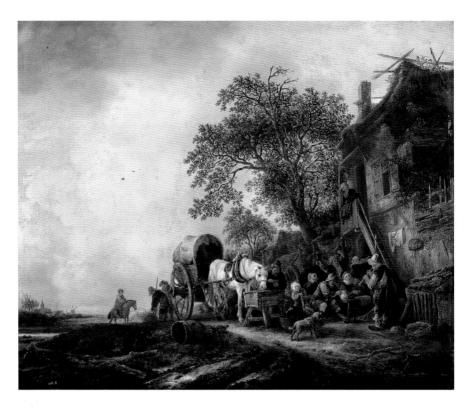

Isack van Ostade 1621–1649

Van Ostade was born in Haarlem and worked there throughout his short career. He studied with his older brother Adriaen, whose scenes of peasant cottages and taverns were the chief inspiration for his early work. A prolific painter, Isack later turned to outdoor genre subjects and winter landscapes.

Travelers Halting at an Inn

Oil on oak panel, $20\frac{1}{8} \ge 24\frac{1}{2} (51.1 \ge 62.2)$ Signed: *Isack. Ostade.* Date unknown. 07.1.91

Like his more famous brother and other Haarlem painters, van Ostade was much attracted by the picturesque animation of country inns. He treated aspects of this theme often, typically, as here in landscapes enriched by subtle effects of silvery daylight.

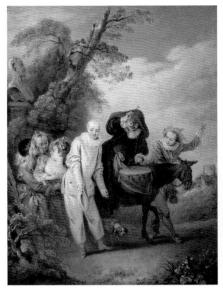

Procession of Italian Comedians

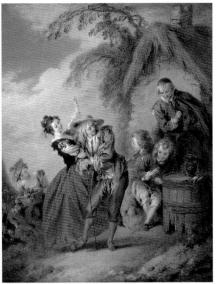

The Village Orchestra

Jean-Baptiste Pater 1695–1736

Born in Valenciennes, Pater received his artistic training from his fellow townsman Jean-Antoine Watteau, whom he accompanied to Paris about 1710. The two later parted because of temperamental differences, but in 1721 Watteau, mortally ill, made peace with Pater, who appears to have inherited his unfinished paintings and some commissions. Pater was elected to the Academy in 1728 as a painter of fêtes galantes.

Procession of Italian Comedians Oil on canvas, 29¹/4 x 23³/8 (74.3 x 59.4) Date unknown. 18.1.92

The Village Orchestra Oil on canvas, $293/8 \ge 231/2$ (74.6 ≥ 59.7) Date unknown. 18.1.93

Though these two paintings seem to have been regarded as pendants as early as 1739, when they were engraved, they have no precise iconographical relationship. The stock characters who appear in the *Procession*—including from the left Pantaloon, Harlequin, Columbine, Pierrot, the Doctor, and Scapin—were popularized by contemporary *commedia dell'arte* players. In contrast, *The Village Orchestra* evokes the simple pleasures of rural life, albeit with an elegant veneer.

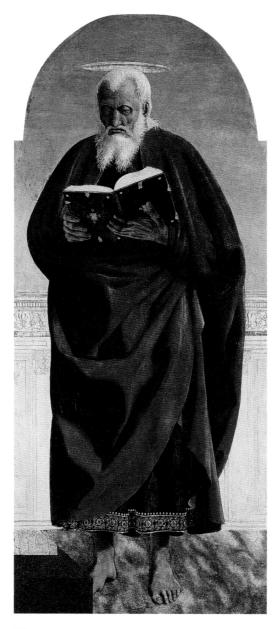

Piero della Francesca 1410/20–1492

Born in the Tuscan town of Borgo Sansepolcro, Piero is first recorded in 1439 assisting Domenico Veneziano in Florence. He also worked in his birthplace and in Ferrara, Rimini, Rome, Urbino, and elsewhere. Piero's best-known paintings form the celebrated fresco cycle depicting the Legend of the True Cross in the church of S. Francesco at Arezzo. In addition to frescoes and altarpieces Piero painted portraits.

St. John the Evangelist

Tempera on poplar panel, $52^{3}/4 \ge 24^{1}/2$ (134 ≥ 62.2) Painted probably between 1454 and 1469. 36.1.1

In 1454 Angelo di Giovanni di Simone d'Angelo ordered from Piero a polyptych for the high altar of S. Agostino in Borgo Sansepolcro. The commission specified that this work, undertaken to fulfill the wish of Angelo's late brother Simone and the latter's wife, Giovanna, for the spiritual benefit of the donors and their forebears, was to consist of several panels with "images, figures, pictures, and ornaments." The central portion of the altarpiece is lost, but four lateral panels with standing saints-St. Michael the Archangel (National Gallery, London), St. Augustine (Museu Nacional de Arte Antiga, Lisbon), St. Nicholas of Tolentino (Museo Poldi-Pezzoli, Milan), and the present panel-have survived. The venerable figure in the Frick painting is presumed to represent St. John the Evangelist, patron saint of the donors' father and of Simone's wife. Evidence from a payment made to Piero in 1469 suggests that the altarpiece was finished late that year, fifteen years after the original contract. The lengthy delay resulted no doubt from Piero's many other commitments during this period, when he traveled to towns all across Central Italy and contracted obligations to patrons more important-and more exigent-than the family of Angelo di Giovanni and the Augustinian monks of his own small town, Borgo Sansepolcro.

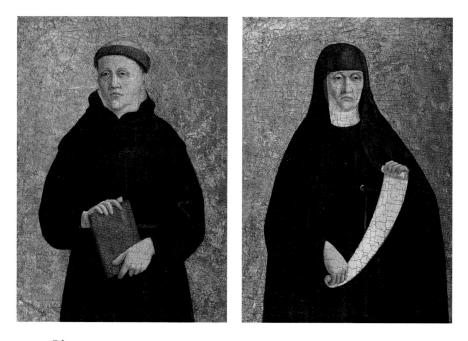

Piero Augustinian Monk

Tempera on poplar panel, 15³/₄ x 11¹/₈ (40 x 28.2) Date unknown. 50.1.157

Augustinian Nun

Tempera on poplar panel, $15^{1/4} \ge 11$ (38.7 ≥ 27.9) Date unknown. 50.1.158

These two small panels probably belonged to a set of four recorded in the nineteenth century at Borgo Sansepolcro. A St. Apollonia now in the National Gallery of Art, Washington, D.C., is presumed to be another from this series; a fourth panel, of an unidentified saint, was cited in the same inventory but has since disappeared. All are believed to have formed subsidiary parts of Piero's S. Agostino altarpiece (see preceding entry). While the subjects of the Frick panels wear Augustinian habits, they lack distinctive attributes. They may represent the Blessed Angelo Scarpetti, the most revered local Augustinian monk, who was buried beneath the high altar of S. Agostino, and St. Monica, mother of St. Augustine and putative founder of the order of Augustinian nuns. Although the figures in the small panels are close to Piero's style in their dignity and austerity, some have doubted that they were executed by Piero himself. A number of talented artists assisted Piero in his many commissions, which he often undertook to execute simultaneously in widely separated locations.

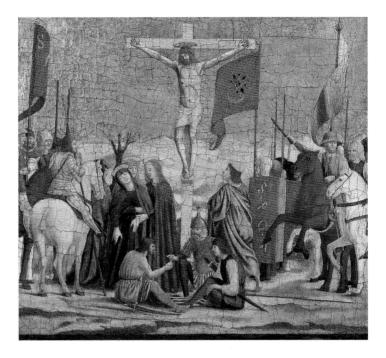

Piero The Crucifixion

Tempera on poplar panel, $14^{3}/_{4} \ge 16^{3}/_{16} (37.5 \ge 41.1)$ Date unknown. Bequest of John D. Rockefeller, Jr., 61.1.163

It has been proposed by some writers that this Crucifixion, like the preceding two panels portraving an Augustinian monk and nun, originally formed a part of Piero's S. Agostino altarpiece, probably as one of the predella scenes. The first known reference to The Crucifixion is found in a seventeenth-century document describing paintings in the collection of Luca and Francesco Ducci at Borgo Sansepolcro. The Crucifixion, one of four "quadretti" attributed to Piero, is described there in considerable detail. The other subjects were a Flagellation, a Deposition, and a Resurrection, all of them now lost. The writer did not claim that these predella panels came from the S. Agostino altarpiece, although in the same collection-in another room of the house-were four larger panels of standing saints discussed in the earlier entry on Piero's St. John. The seventeenth-century record does not, therefore, resolve the problem of whether or not The Crucifixion also belonged to this altarpiece. The question of possible workshop participation in painting The Crucifixion is also an unresolved issue. A number of scholars believe that an assistant was responsible for the execution, although certain passages of this small yet monumental composition are painted with great refinement.

Carel van der Pluym 1625–1672

Van der Pluym was born and lived in Leyden, where his family were official city plumbers and where the young artist became a charter member of the painters' guild in 1648. He was a cousin of Rembrandt, with whom he may have studied and whose style he imitated.

Old Woman with a Book Oil on canvas, 385/8 x 303/4 (98.1 x 78.1) Date unknown. 16.1.99

Like many other pictures of old women done in the style of Rembrandt, this canvas was once believed to be a portrait by that artist of his mother. However, the coloring and modeling more closely resemble those of the few signed works by van der Pluym.

Sir Henry Raeburn 1756–1823

By his early twenties Raeburn had established himself as a painter of portraits and miniatures in his native Edinburgh. From 1785 to 1787 he worked in Rome on the advice of Reynolds, and soon after his return he became the leading portraitist in Scotland. He was elected to the Royal Academy in 1815 and named His Majesty's Limner for Scotland in 1822.

James Cruikshank

Oil on canvas, 50 x 40 (127 x 101.6). Date unknown. 11.1.94

James Cruikshank (d. 1830) of Montrose, Forfarshire, was a businessman who made a large fortune from sugar plantations in the British West Indies. Although no record of the commission for Raeburn's portraits of Cruikshank and his wife has been found, a dating of between 1805 and 1808 has been suggested on stylistic grounds.

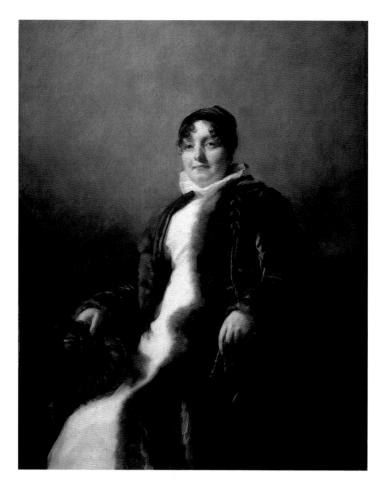

Raeburn Mrs. James Cruikshank Oil on canvas, 50³/4 x 40 (128.9 x 101.6) Date unknown, 05.1.95

Margaret Helen Gerard, daughter of an Aberdeen minister, married James Cruikshank in 1792 and died in 1823. Raeburn's companion portraits of the Cruikshanks were separated for a number of years before being reunited in Mr. Frick's collection in 1911.

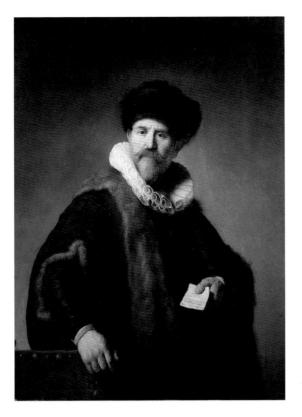

Rembrandt Harmensz. van Rijn 1606–1669

Born in Leyden, Rembrandt studied there and later worked in Amsterdam under Pieter Lastman. About 1625 he returned to Leyden, where he taught the first of his many pupils, but in 1631/32 he settled permanently in Amsterdam, quickly achieving success as a painter of single and group portraits, biblical scenes, and historical subjects. He also executed numerous etchings and drawings.

Nicolaes Ruts

Oil on mahogany panel, 46 x 343/8 (116.8 x 87.3) Signed and dated: R[H?]L. 1631. 43.1.150

Nicolaes Ruts (1573–1638) was an Amsterdam merchant who traded with Russia, the source no doubt of the rich furs he wears in this painting. Perhaps the first portrait commission Rembrandt received from outside his own family, the picture must have contributed to his rapid rise to fame. The dramatic contrasts in lighting and the detailed rendering of the varied textures are characteristic of Rembrandt's early production, differing markedly from the warm, diffused light and broad brushwork that distinguish the Frick *Self-Portrait* painted more than a quarter of a century later.

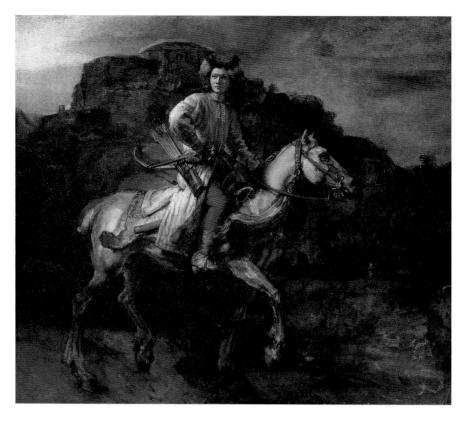

Rembrandt

The Polish Rider

Oil on canvas, 46 x 53¹/8 (116.8 x 134.9) Signed: *R[e?]*. Painted about 1655. 10.1.98

Ranked among Rembrandt's most impressive and moving works, this enigmatic depiction of a young warrior riding resolutely through a shadowy landscape has evoked many interpretations, all of them inconclusive. It is not a conventional equestrian portrait, nor does it appear to represent a historical or literary figure, though a number have been proposed. Rembrandt may have meant only to portray an exotic horseman, a popular contemporary theme, or perhaps intended the painting as a glorification of the latter-day Christian knights who in his time were still defending eastern Europe from the advancing Turks.

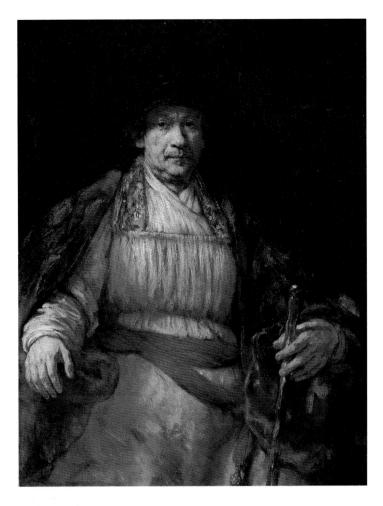

Rembrandt Se

Self-Portrait

Oil on canvas, 525/8 x 407/8 (133.7 x 103.8) Signed and dated: *Rembrandt/f*.1658. 06.1.97

Rembrandt painted more than sixty self-portraits and drew and etched his likeness repeatedly. These works range from youthful efforts that often served as experiments in dramatic lighting effects or transitory facial expressions to the more subtle and searching images of his mature years. The Frick canvas, with its psychological depth, monumental design, and rich, warm coloring, is surely the most imposing of these portraits. The artist, poor and burdened with personal problems, depicted himself—in poignant and perhaps ironic contrast—in the splendid costume and enthroned dignity of an Oriental monarch.

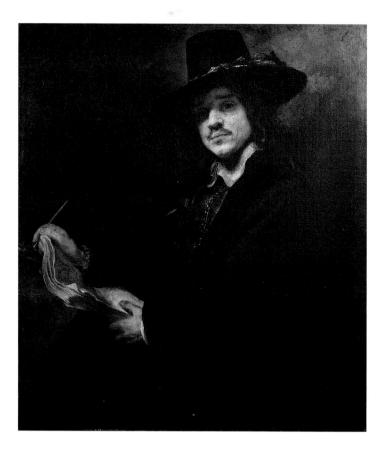

Follower of Rembrandt

Portrait of a Young Artist Oil on canvas, 391/8 x 35 (99.4 x 88.9) Spurious signature and date: *Rembrandt f:/164[7?]* 99.1.100

The identity of the subject remains in question, though he has at times been called Leonaert Bramer, Carel Fabritius, Jan van de Cappelle, and Jan Asselyn. The painting is in the style of Rembrandt's portraits of the late 1640s, but it could well be the product of a pupil or imitator. Mr. Frick's purchase of this canvas in 1899 signaled a new stage in his development as a collector; previously he had favored the work of contemporary French Academic and Barbizon painters.

Pierre-Auguste Renoir 1841–1919

Renoir began his career as a painter of porcelain and at twenty-one enrolled in the Paris École des Beaux-Arts. He first showed at the Salon in 1864, and ten years later he took part in the first Impressionist exhibition. After visits to Algeria and Italy in 1881–82, his work began to diverge from that of the Impressionists.

Mother and Children

Oil on canvas, 67 x 425/8 (170.2 x 108.3) Signed: *Renoir*. Painted probably about 1874–76. 14.1.10

In 1876 Renoir rented a new studio at the top of Montmartre with funds he had received for a portrait of a mother and her two little girls, very possibly the Frick canvas. Such pleasing portraits brought the artist success at a time when his fellow Impressionists were having difficulty selling their works.

Sir Joshua Reynolds 1723–1792

Reynolds served as apprentice under Thomas Hudson before launching his career in his native Plymouth. Between 1749 and 1752 he was in Italy, where the study of ancient art and the Italian masters profoundly affected his style. Soon after his return he became the most fashionable portraitist in London. As first president of the Royal Academy, he delivered a series of "Discourses" that were highly influential in shaping British aesthetic theory.

General John Burgoyne

Oil on canvas, 50 x 397/8 (127 x 101.3) Painted probably in 1766. 43.1.149

Best remembered as the British commander who in 1777 surrendered to American forces at Saratoga, John Burgoyne (1722–1792) was also a dandy, gambler, actor, amateur playwright, and Member of Parliament. This portrait may have been commissioned by his senior officer, Count La Lippe, as a memento of their Portuguese campaign of 1762. Burgoyne's uniform is that of the Sixteenth Light Dragoons as it was worn until May 1766.

Reynolds Elizabeth, Lady Taylor

Oil on canvas, 50¹/8 x 40¹/4 (127.3 x 102.2) Painted about 1780. 10.1.101

The subject is thought to have been Elizabeth Goodin Houghton, who married Sir John Taylor in 1778 and died in 1831. However, a number of clients named Taylor were painted by Reynolds, whose abbreviated, often illegible records of payments make it difficult to identify sitters or to date works accurately. The dress and tall plumed hat suggest that the portrait was executed in the late 1770s or early 1780s.

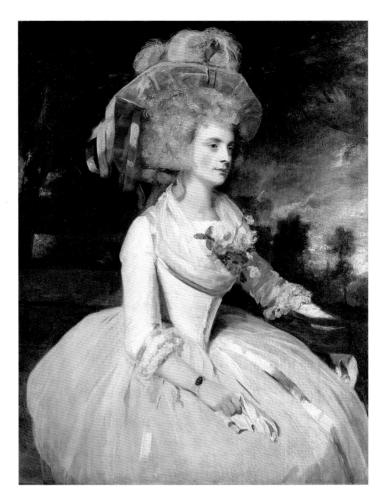

Reynolds Selina, Lady Skipwith Oil on canvas, 50¹/2 x 40¹/4 (128.3 x 102.2) Painted in 1787. 06.1.102

Selina Shirley (1752–1832) was married in 1785 to Sir Thomas George Skipwith of Newbold Hall, Warwickshire. Lady Skipwith had a reputation as a skilled horsewoman, and a nephew records that "there was something rather formidable in her powdered hair and [the] riding habit or joseph which she generally wore." Reynolds's notebooks show that he painted her in May 1787. The natural pose and setting and fresh, free handling of paint are typical of the artist's late style.

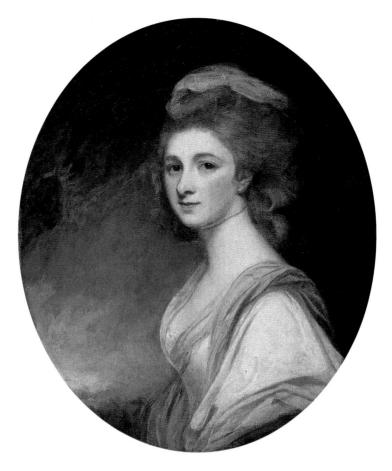

George Romney 1734–1802

Before moving to London in 1762, Romney had studied and achieved some success in the north of England. He visited Paris in 1764, and from 1773 until 1775 he lived in Italy. He was a prolific artist who rivaled Reynolds as a fashionable portraitist.

Miss Frances Mary Harford

Oil on canvas, 30 x 25¹/4 (76.2 x 64.1) Painted between 1780 and 1738. 03.1.105

Born about 1759, Frances Harford was the natural daughter of Frederick Calvert, seventh Lord Baltimore, whose family had founded the province of Maryland. Bequeathed a large sum by her father, she was married at thirteen to her guardian, Robert Morris. After this union was declared void twelve years later, she married the Hon. William Frederick Wyndham, youngest son of the second Earl of Egremont. The records of sittings in Romney's diaries indicate that he painted three or four portraits of Miss Harford.

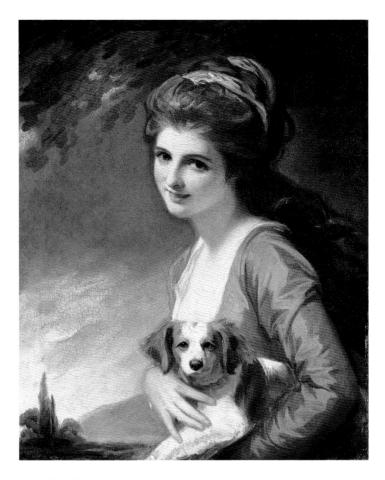

Romney Lady Hamilton as 'Nature' Oil on canvas, 297/8 x 24³/4 (75.8 x 62.9) Painted in 1782. 04.1.103

Emma Lyon (1765–1815), who later in life called herself Emily Hart, was the daughter of a Cheshire blacksmith. A fascinating personality and beauty, she was in turn the mistress of the Hon. Charles Greville, who commissioned this portrait, of Sir William Hamilton, Greville's uncle and British envoy to Naples, whom she married in 1791, and of Lord Nelson, with whom she lived until his death in 1805. She died in poverty in Calais. At the height of her social success, Lady Hamilton was famous for her "attitudes" —a kind of romantic aesthetic posturing. Romney painted more than twenty portraits of his "divine lady," many in the guise of characters from history, mythology, and literature.

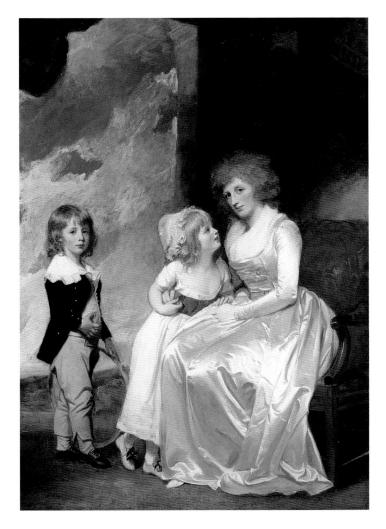

Romney Henrietta, Countess of Warwick, and Her Children Oil on canvas, 79³/₄ x 61¹/₂ (202.6 x 156.2) Painted 1787–89. 08.1.107

Henrietta Vernon (1760–1838), daughter of Richard Vernon, the so-called Father of the Turf, became at sixteen the second wife of George Greville, Earl of Warwick. Horace Walpole mentioned her and her sisters in his letters and also wrote verses to them. Romney has depicted her with two of her children, presumably Henry Richard and Elizabeth, in a composition that recalls the group portraits Van Dyck painted in England.

Romney Miss Mary Finch-Hatton Oil on canvas, 297/8 x 251/8 (75.8 x 63.8) Painted in 1788. 98.1.104

> Mary Finch-Hatton, daughter of John Finch-Hatton of Long Stanton Hall, near Cambridge, married Hale Wortham of Royston, Hertfordshire. Romney's notebooks record six sittings for this portrait of her, which in its bold and summary brushwork resembles the technique of the artist's numerous wash drawings.

Romney Charlotte, Lady Milnes Oil on canvas, 95¹/₈ x 58³/₄ (241.6 x 149.2) Painted 1788–92. 11.1.106

Charlotte Frances Bentinck (1767/68–1850) was married in 1785 to Robert Shore Milnes, who ten years later became Governor of Martinique and in 1798 was named Lieutenant-Governor of Lower Canada. Milnes, a longtime patron of Romney, commissioned this rather classicizing portrait in 1788, along with one of himself now at Helperby, Yorkshire.

Pierre-Étienne-Théodore Rousseau 1812–1867

Rousseau was born and trained in Paris, where he was much influenced by the Dutch landscapes in the Louvre. He began exhibiting at the Salon in 1831 but had little success until 1849, when he won a first-class medal and considerable public acclaim. After the Revolution of 1848 he settled in the village of Barbizon with Millet, Daubigny, and others of the group that came to be known as the Barbizon School.

The Village of Becquigny

Oil on mahogany panel, 25 x 39³/8 (63.5 x 100) Signed: *TH. Rousseau*. Begun about 1857. 02.1.108

During his last ten years Rousseau frequently revised this panel representing a village in Picardy, a composition that clearly recalls seventeenth-century Dutch landscapes. The day before sending the picture to the Salon of 1864 he altered the sky to a bright sapphire blue, in imitation of the first Japanese prints he had seen, but the color was so widely criticized that he later restored the original softer hues. The artist's friends considered this one of his most important and successful achievements.

Sir Peter Paul Rubens, Follower of Seventeenth Century

Rubens (1577–1640) worked in Italy, Spain, England, and France as well as in his native Flanders, where he directed a large workshop employing numerous assistants. His style influenced many of his contemporaries throughout Europe.

A Knight of the Order of the Golden Fleece Oil on canvas, $39^{3/4} \ge 30^{1/2}$ (101 ≥ 77.5) Date unknown. 15.1.109

Once ascribed to Rubens himself, this work has since been assigned, with insufficient evidence, to various of his collaborators, including Van Dyck, Snyders, and Cornelis de Vos. A version in the New-York Historical Society, attributed to de Vos, is identified as a portrait of Ambrogio Spinola, who was commander of Spanish forces in the Netherlands and a friend of Rubens. A copy of the portrait, or of its prototype, by Chassériau is implausibly said to represent Don Fernando Álvarez de Toledo, third Duke of Alba, who was Spanish Viceroy of the Netherlands and died in 1582.

Jacob van Ruisdael 1628/29–1682

Ruisdael was born in Haarlem and entered the painters' guild there in 1648, presumably after studying with his uncle Salomon van Ruysdael. By 1657 he was living in Amsterdam, where he seems to have spent the rest of his life. His many paintings, drawings, and etchings are devoted entirely to landscape.

Landscape with a Footbridge Oil on canvas, 38³/4 x 62⁵/8 (98.4 x 159.1) Signed and dated: *JRuisdael* 1652. 49.1.156

In 1650 Ruisdael traveled to the province of Overijssel near the Dutch-German frontier and made drawings there of hilly scenery that differs markedly from the flat countryside of western Holland, the chief subject of the earlier Haarlem landscapists. In this painting, completed two years later, the youthful artist demonstrates his special gift for rendering subtle effects of light, evident in the pale sun that filters through the clouds to dapple the landscape and reflect from the surface of the stream.

Ruisdael Quay at Amsterdam Oil on canvas, 20³/8 x 25⁷/8 (51.7 x 65.7) Signed: *[Ruisdael.* Painted about 1670. 10.1.110

> This rare urban scene by Ruisdael shows in the foreground the north end of the Dam, the main square of Amsterdam, and beyond it the broad canal called the Damrak (now filled in). Among the recognizable buildings is the fourteenth-century Oude Kerk, whose tower, altered in 1565, rises at right. Ruisdael painted several views of the square, where he had a studio in his later years.

Salomon van Ruysdael 1600(?)-1670

Ruysdael, an early exponent of the Dutch realist landscape tradition, was born in Naarden, near Amsterdam. In 1623 he became a member of the painters' guild in Haarlem, where he remained until his death. He probably was the teacher of his more celebrated nephew, Jacob van Ruisdael.

River Scene: Men Dragging a Net Oil on canvas, 26¹/₄ x 35¹/₈ (66.7 x 89.2) Painted about 1667. 05.1.111

The town in the background has been identified on the basis of its church and twin-towered gate as Weesp, a community on the Vecht not far from Amsterdam. A riverbank, large trees, fishermen, boats, and distant buildings are motifs that Ruysdael varied and rearranged repeatedly throughout his career. Here they are combined with particularly fine effects of sunset reflected from water.

Gilbert Stuart 1755–1828

Stuart was born in North Kingstown, Rhode Island. After studying in Scotland and working in London under his compatriot Benjamin West, he returned in the early 1790s to become the leading American portraitist of his day. He painted chiefly in New York, Philadelphia, and Boston.

George Washington

Oil on canvas, 29¹/4 x 24 (74.3 x 60.9) Painted 1795–96. 18.1.112

Stuart earned a fortune producing replicas of the three portraits he painted from life of the first President of the United States. The Frick canvas is thought to be a copy the artist made for John Vaughan of Philadelphia and belongs to the group known as the "Vaughan type," though it differs from the related versions in the color of the coat and in the treatment of the background. Stylistically the portrait recalls the work of Stuart's English contemporaries, such as Romney and Hoppner.

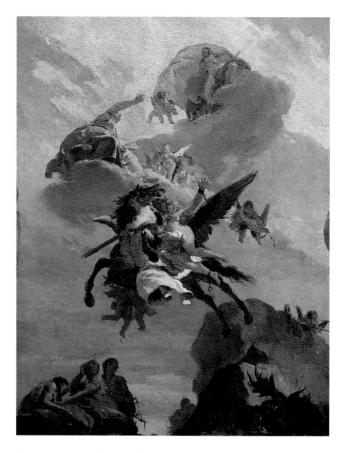

Giovanni Battista Tiepolo 1696-1770

Tiepolo's brilliant talents, especially as a decorator of palaces, villas, and churches, won him fame far beyond his native Venice. He worked for patrons throughout North Italy and received major commissions from Würzburg and Madrid. A prolific artist, he produced religious, historical, and mythological paintings as well as numerous drawings and etchings.

Perseus and Andromeda

Oil on paper affixed to canvas, $203/8 \times 16$ (51.8 x 40.6) Painted probably in 1730. 18.1.114

In Greek myth, the Ethiopian princess Andromeda was chained to a rock by her father as sacrifice to a sea monster sent to ravage his kingdom. Her rescue by Perseus astride Pegasus is the subject of this oil sketch, a study for a ceiling fresco in the Palazzo Archinto, Milan (destroyed by bombing in 1943). The figures, illusionistically conceived to be seen from below, soar upward toward the goldtinged heavens, where Minerva and Jupiter discuss their fate.

Jacopo Tintoretto, Circle of

Jacopo Robusti (1518–1594), called Il Tintoretto, is best known for the religious paintings he produced for Venetian churches and confraternities, but he also executed portraits and mythological and allegorical cycles. His large workshop included his sons Domenico and Marco and daughter Marietta, who along with others perpetuated his style well into the seventeenth century.

Portrait of a Venetian Procurator

Oil on canvas, 445/8 x 35 (113.3 x 88.9) Date unknown. 38.1.142

The crimson robes and black cap and stole worn by the unknown subject of this portrait identify him as a Procurator of St. Mark, a high Venetian official with administrative and charitable duties and a seat in the Senate. Since the distant view of the island of S. Giorgio Maggiore at right does not include Palladio's church of S. Giorgio, the cornerstone of which was laid in 1566, the portrait or its prototype presumably was painted before that date.

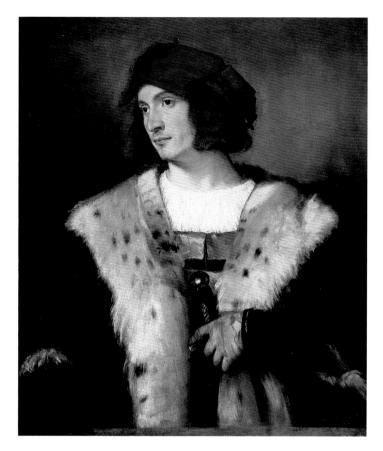

Titian (Tiziano Vecellio) 1477/90–1576

Titian was born in the Alpine town of Pieve di Cadore; the date of his birth is uncertain. He succeeded Giovanni Bellini, under whom he had studied, as painter to the Republic of Venice, and he included among his many illustrious patrons the Emperor Charles V, Charles's son Philip II of Spain, and Pope Paul III. He died in Venice in the great plague of 1576.

Portrait of a Man in a Red Cap Oil on canvas, 32³/8 x 28 (82.3 x 71.1) Painted about 1516. 15.1.116

This portrait of a richly dressed young man is generally considered an early work of Titian. The contemplative mood of the subject and the diffused, gentle play of light over broadly painted surfaces are strongly reminiscent of Titian's Venetian contemporary Giorgione, to whom the canvas has in the past been attributed.

Titian Pietro Aretino

Oil on canvas, $40\frac{1}{8} \ge 33\frac{3}{4}$ (102 x 85.7) Painted probably between 1548 and the early 1550s 05.1.115

Pietro Aretino (1492–1556), author of scurrilous verses, lives of saints, comedies, tragedies, and innumerable letters, also attained considerable wealth and influence through literary flattery and blackmail. He was on intimate terms with Titian, who painted at least three portraits of him. Here the artist conveys a sense of his friend's intellectual power through the keen, forceful head and of his worldliness through the solid, rounded mass of the richly robed figure.

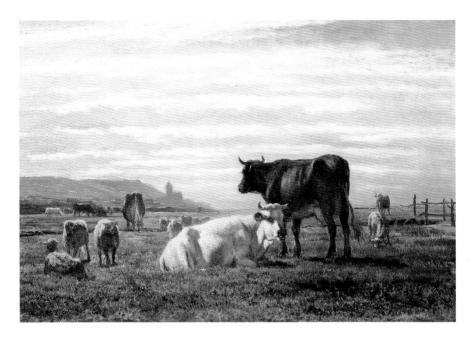

Constant Troyon 1810–1865

The son of a painter at the Sèvres porcelain works, Troyon received his first lessons from the factory manager. He later became associated with Rousseau, Dupré, and others of the Barbizon group. A prize awarded him in 1846 made possible a visit to Holland, where he was much influenced by the Dutch landscapists, especially Cuyp and Potter.

A Pasture in Normandy

Oil on panel, 17 x 255/8 (43.2 x 65.1) Signed: C. TROYON. Painted in the 1850s. 99.1.117

At the insistence of his friends, Troyon began in the 1840s adding to his landscapes the figures of animals he had sketched in barns when inclement weather prevented him from working outdoors. By 1855 he was well known throughout Europe not only as a landscape painter but particularly as an *animalier*. The background in the Frick picture appears again, viewed from a slightly different angle, in two other Troyon compositions.

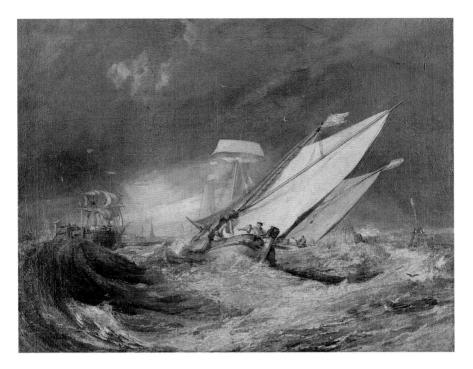

Joseph Mallord William Turner 1775–1851

Turner, the son of a London barber, studied at the Royal Academy, to which he was granted full membership at the age of twenty-seven. Known initially as a watercolorist, he began exhibiting oils in the mid-1790s. He traveled extensively in England and on the Continent and made innumerable sketches, many of which he used as the basis for paintings and prints.

Fishing Boats Entering Calais Harbor Oil on canvas, 29 x 38³/4 (73.7 x 98.4) Painted about 1803. 04.1.120

In July 1802, during the temporary Peace of Amiens, Turner began his first visit to the Continent. He recorded his arrival at Calais in several sketches, which he later worked up into this canvas and the much larger *Calais Pier* now in the National Gallery, London. The churning waters and stormy skies in both works recall Dutch seascapes of the seventeenth century.

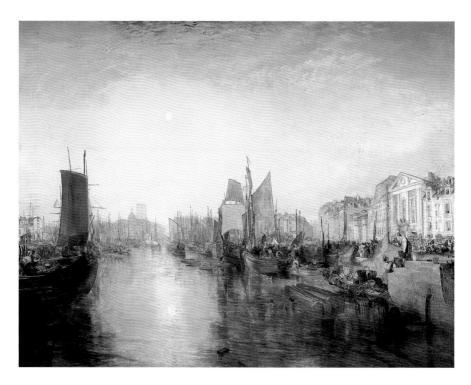

Turner The Harbor of Dieppe Oil on canvas, 68³/8 x 88³/4 (173.7 x 225.4) Dated: 182/6?]. 14.1.122

Dieppe is one of several large exhibition pieces Turner painted representing northern Continental ports (see also the following entry). Sketches for it date from the late summer of 1821 and record a number of buildings that still stand. The intense luminosity of the painting displeased many contemporary critics, one of whom called it a "splendid piece of falsehood." Another, however, wrote, "Not even Claude in his happiest efforts, has exceeded the brilliant composition before us."

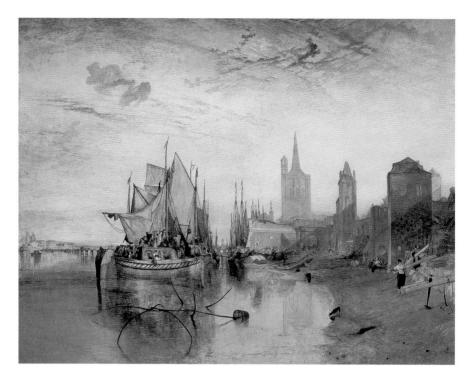

Turner Cologne: The Arrival of a Packet-Boat: Evening Oil and possibly watercolor on canvas, 66³/₈ x 88¹/₄ (168.6 x 224.1). Painted in 1826, 14.1.119

> According to an account of Ruskin's, Turner quixotically covered the golden sky of this painting with a wash of lampblack during the Royal Academy exhibition of 1826 in order not to detract from two portraits by Lawrence that hung to either side of it. However, contemporary critical references to its "glitter and gaud of colors" as well as to the delicate nature of its surface medium cast doubt on Ruskin's anecdote. The composition is based on sketches Turner made while touring the Rhine in 1817 and again in 1825.

Turner Mortlake Terrace: Early Summer Morning Oil on canvas, 365/8 x 481/2 (93 x 123.2) Painted in 1826. 09.1.121

This canvas painted for William Moffatt depicts Moffatt's estate at Mortlake, on the Thames just west of London. Like so many of Turner's works, it is based on numerous preparatory drawings, in which the artist recorded the topography and studied various ways of balancing the mass of the house and land against the open river and sky. A companion view of the terrace and river on a summer evening as seen from a ground-floor window of the house is in the National Gallery of Art, Washington, D.C.

Turner Antwerp: Van Goyen Looking Out for a Subject Oil on canvas, 36¹/8 x 48³/8 (91.8 x 122.9) Painted in 1833. 01.1.118

> The reference in the painting's title and the inscription VAN G on the stern of the nearest boat identify the turbaned figure standing in that vessel as the Dutch landscapist Jan van Goyen. Like Turner, van Goyen visited Antwerp and executed paintings based on sketches done there. This allusion to a seventeenth-century Dutch painter is not unique in Turner's titles—witness his *Rembrandt's Daughter* and *Port Ruysdael*.

Diego Rodríguez de Silva y Velázquez 1599–1660

Velázquez was born in Seville and apprenticed there to Francisco Pacheco. In 1623 he entered the service of Philip IV, to whom he became both official painter and personal friend. Apart from visits to Italy in 1629–31 and 1649–51, he remained at the Spanish court until his death.

King Philip IV of Spain Oil on canvas, 511/8 x 391/8 (129.8 x 99.4) Painted in 1644. 11.1.123

Philip IV (1605–1665), who succeeded to the throne in 1621, was a weak ruler but a lavish patron of the arts and letters. He promoted the Spanish theater, built the Palacio del Buen-Retiro at Madrid, enlarged the royal collections, and was Velázquez's most ardent supporter. In 1644 Velázquez accompanied the King to Fraga, where on May 15 the Spaniards won an important victory over the French. There, in a dilapidated, makeshift studio, Philip posed for this portrait dressed in the silver-and-rose costume he wore during the campaign.

Paolo and Giovanni Veneziano Paolo, Active 1321–1358

Paolo Veneziano is considered the leading figure of Venetian trecento painting. Little is known of his son Giovanni beyond his participation in the Frick panel and in the painted cover, dated 1345, for the Pala d'Oro in St. Mark's, Venice.

The Coronation of the Virgin

Tempera on poplar panel, $43^{1}/4 \ge 27$ (110 ≥ 68.5) Signed and dated: M.C.C.C.L.V.I.I.I. / PAVLUS CVM / IOHANINVS EIV/ FILIV / PISERVT HOC OP. [1358]. 30.1.124

The Coronation of the Virgin is recounted not in the New Testament but in the apocryphal story of the Virgin's death. In many Coronation scenes painted by Paolo and other Venetian artists a sun and a moon accompany the principal figures, the sun from early times being associated with Christ and the moon with the Virgin. The angels singing and playing musical instruments in the Frick panel symbolize the harmony of the universe; their instruments are the authentic components of a medieval orchestra, accurately depicted and correctly held and played.

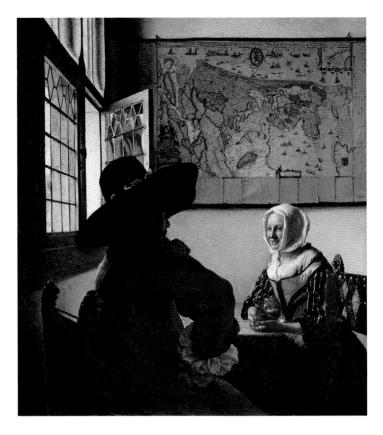

Johannes Vermeer 1632–1675

Vermeer seems to have spent his whole life in Delft, where he joined the painters' guild in 1653. His work shows the influence of Carel Fabritius, who may have been his teacher, and of the Caravaggesque painters of Utrecht. Though his pictures apparently commanded high prices, he produced relatively few; only thirty-five to forty paintings are generally recognized as from his hand.

Officer and Laughing Girl

Oil on canvas, 197/8 x 181/8 (50.5 x 46) Painted probably about 1655–60. 11.1.127

In what may be one of the first works of his mature style, Vermeer transforms the theme of a girl entertaining her suitor, already popular in Dutch art, into a dazzling study of light-filled space. The dark foil of the officer's silhouette dramatizes both the illusion of depth and the brilliant play of light over the woman and the furnishings of the chamber. The map of Holland on the far wall, first published in 1621, also appears in two other paintings by Vermeer.

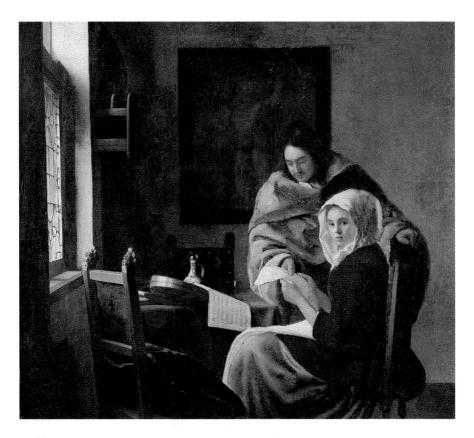

Vermeer Girl Interrupted at Her Music Oil on canvas, 15¹/₂ x 17¹/₂ (39.3 x 44.4) Painted about 1660. 01.1.125

Music-making, a recurring subject in Vermeer's interior scenes, was associated in the seventeenth century with courtship. In this painting of a duet or music lesson momentarily interrupted, the amorous theme is reinforced by the picture of Cupid with raised left arm dimly visible in the background; the motif is derived from a popular book on emblems of love published in 1608 and symbolizes fidelity to a single lover. Vermeer's treatment of light, space, and the relationship between the two figures is subtler and more complex here than in the *Officer and Laughing Girl*, which probably dates from a few years earlier.

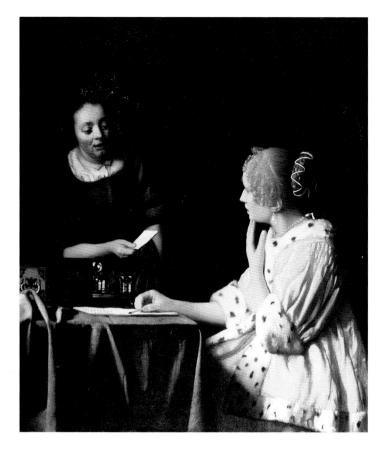

Vermeer Mistress and Maid Oil on canvas, 35¹/2 x 31 (90.2 x 78.7)

Painted probably about 1665–70. 19.1.126

The lack of final modeling in the mistress's head and figure indicates that this late work by Vermeer was left unfinished. Nevertheless, the artist seldom if ever surpassed the subtly varied effects of light seen here as it gleams from the pearl jewelry, sparkles from the glass and silver objects on the table, and falls softly over the figures in their shadowy setting. Exceptional too is the sense of dramatic tension expressed by the two women arrested in some moment of mysterious crisis. Bought by Mr. Frick in 1919, the year of his death, this painting was his last purchase and joined Rembrandt's *Self-Portrait*, Holbein's *Sir Thomas More*, Bellini's *St. Francis*, and Velazquez's *King Philip IV* among his favorite acquisitions.

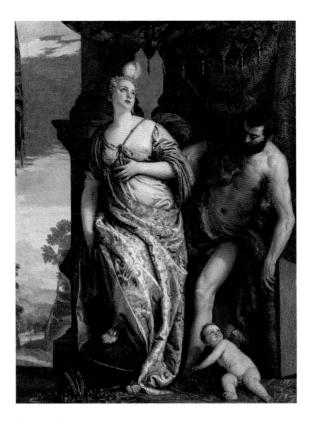

Paolo Veronese c. 1528–1588

Paolo Caliari was called Il Veronese after his birthplace, Verona. A master of color, illusionism, and pageantry, he painted monumental religious, mythological, and allegorical works as well as magnificent decorations for the villas of patrician families. Except for a visit to Rome about 1560 he passed most of his mature life in and around Venice.

Allegory of Wisdom and Strength

Oil on canvas, 84¹/2 x 65³/4 (214.6 x 167) Date unknown. 12.1.128

Veronese expresses the moralizing theme of this picture in sumptuous style. The female figure gazing heavenward is generally thought to represent Divine Wisdom, with the traditional attribute of a sun over her head. The shadowed Hercules, his gaze fixed on the riches strewn over the ground, would appear here to symbolize earthly power or physical strength. The inscription OMNIA VANITAS (All is Vanity) at the lower left is the keynote of the Book of Ecclesiastes, which stresses the supremacy of divine wisdom over worldly things and the labors that produce them.

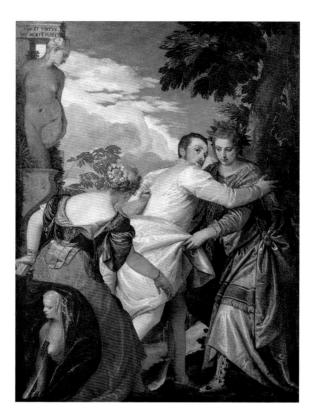

Veronese Allegory of Virtue and Vice (The Choice of Hercules) Oil on canvas, 86¹/4 x 66³/4 (219 x 169.5) Date unknown. 12.1.129

Probably created as a pendant to the previous painting, this allegory represents a variation on the Choice of Hercules, a highly popular theme in Renaissance art and literature. According to the legend, the young hero, finding himself at a crossroads, resists the enticements of Vice, who indicates a path of ease and pleasure, and follows instead Virtue, who offers a rugged lifelong ascent that will ultimately lead to true happiness. The motto on the entablature, [HO]NOR ET VIRTVS/ [P]OST MORTĒ FLORET (Honor and Virtue Flourish after Death), reinforces the moral significance of the subject. Because of the hero's distinctive physiognomy and elegant sixteenth-century costume, this picture has sometimes been considered an allegorizing portrait, perhaps of the artist.

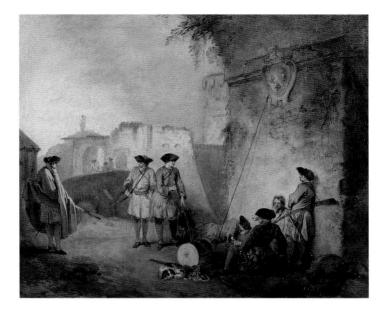

Jean-Antoine Watteau 1684–1721

Born at Valenciennes, Watteau went to Paris in 1702 and became a member of the Academy in 1717. Among his patrons was the great collector Pierre Crozat. Watteau visited London in 1719–20 and died soon after from tuberculosis at the age of thirty-seven. He is chiefly noted for his paintings of theatrical characters and fêtes galantes.

The Portal of Valenciennes

Oil on canvas, 12³/₄ x 16 (32.5 x 40.5) Painted 1709–10 Purchased with funds from the bequest of Arthemise Redpath 91.1.173

The site of this small painting appears to be outside the fortifications of Watteau's birthplace in northern France, Valenciennes, where he visited in 1709. Seven soldiers are dozing or lounging in the early morning light, while others can be seen in the distance. Between 1709 and 1714, Watteau painted a series of military scenes. Far from glorifying battles, these works dwell on the peripheral incidents and activities of warfare. The subtle hues and warm light of this quiet picture, as well as the delicate touch of the artist's brush in rendering the details of figures, costumes, and setting, look forward to the more familiar scenes of theater and romantic dalliance painted later in Watteau's career.

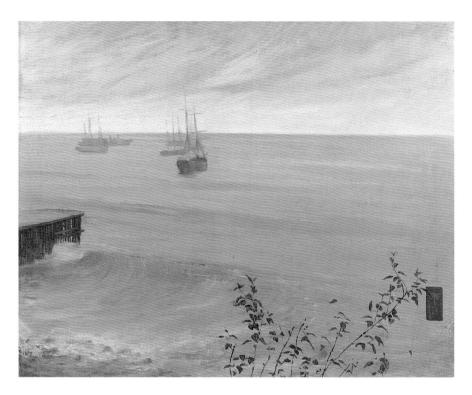

James Abbott McNeill Whistler 1834–1903

Born in Lowell, Massachusetts, Whistler spent part of his childhood and his mature life in Europe. After three years at the West Point Military Academy, he went to London and then Paris. He exhibited in the Salon des Refusés in 1863, and throughout his career he associated with his more experimental contemporaries. His wit as well as his advanced style of painting involved him in many lively controversies.

The Ocean

Oil on canvas, $31^{3}/4 \ge 40^{1}/8 \pmod{80.7 \ge 101.9}$ Signed with the butterfly monogram. Painted in 1866 14.1.135

This painting, exhibited in London in 1892 as *Symphony in Grey and Green: The Ocean*, was one of several seascapes Whistler painted in 1866 during a visit to Valparaiso, Chile. The influence of Japanese prints on his work is apparent here in the high horizon, the decorative arrangement of bamboo sprays, and the signature label at lower right. Both picture and frame—the latter designed by the artist himself—bear Whistler's characteristic butterfly monogram.

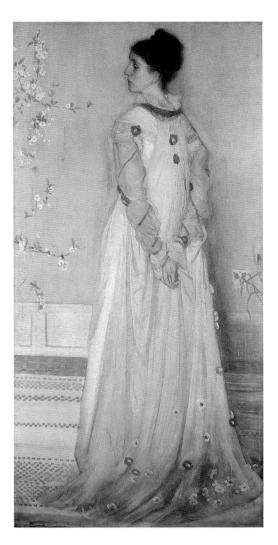

Whistler Symphony in Flesh Colour and Pink: Portrait of Mrs. Frances Leyland Oil on canvas, 77¹/8 x 40¹/4 (195.9 x 102.2) Signed with the butterfly monogram. Painted 1872–73 16.1.133

Frances Dawson (1834–1910) was the wife of Frederick R. Leyland, a Liverpool shipowner who was one of Whistler's chief patrons before they quarreled bitterly. The artist painted the famous Peacock Room now in the Freer Gallery of Art, Washington, D.C., for the Leylands' London townhouse. The Frick portrait apparently was never completely finished. Most of the surviving preparatory drawings are studies for Mrs. Leyland's gown, which Whistler designed.

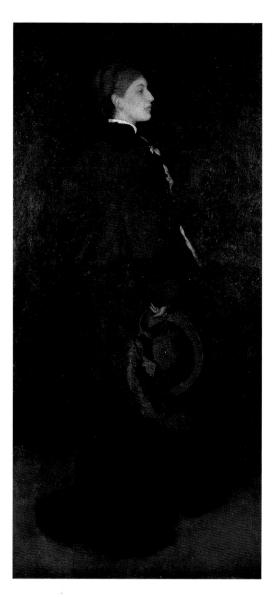

Whistler Arrangement in Brown and Black: Portrait of Miss Rosa Corder Oil on canvas, 75³/4 x 36³/8 (192.4 x 92.4) Painted in 1876–78. 14.1.134

> Rosa Corder was a painter and the mistress of Whistler's unofficial agent, Charles Howell. It is said that Whistler observed her in Chelsea one day wearing a brown dress and passing before a black door and, struck by the color effect, used it as the basis for this portrait. Miss Corder later reported that she had posed for the picture some forty times. An acquaintance remembered her as a person of "a beautiful stillness."

Whistler Harmony in Pink and Grey: Portrait of Lady Meux Oil on canvas, 76¹/4 x 36⁵/8 (193.7 x 93) Signed with the butterfly monogram. Painted in 1881–82 18.1.132

> Susan Langdon (also known as Valerie Susie Reece, 1852–1910), daughter of a Devonshire butcher and victualer, married Sir Henry Bruce Meux, Bart., a brewer. A colorful figure in society, she once created a sensation by appearing at a hunt riding an elephant. This is the second of three portraits Whistler made of her. The first portrait, *Arrangement in Black and White*, is in the Honolulu Academy of Arts, and the third apparently was destroyed by the artist before it was completed as the result of a quarrel with the subject.

Whistler Arrangement in Black and Gold: Comte Robert de Montesquiou-Fezensac Oil on canvas, 82¹/8 x 36¹/8 (208.6 x 91.8) Signed with the butterfly monogram. Painted 1891–92 14.1.131

> Comte Robert de Montesquiou-Fezensac (1855–1921) was a prominent figure in the social and intellectual world of Paris at the turn of the twentieth century. Though he published numerous volumes of poetry, he is probably best remembered as one of the models for the character of Baron de Charlus in Proust's À *la recherche du temps perdu*. Whistler, who received as partial payment for this portrait an Empire bed presented to Montesquiou's ancestors by Napoleon, quoted the delighted subject as exclaiming before the finished work, "It is the acme of pride."

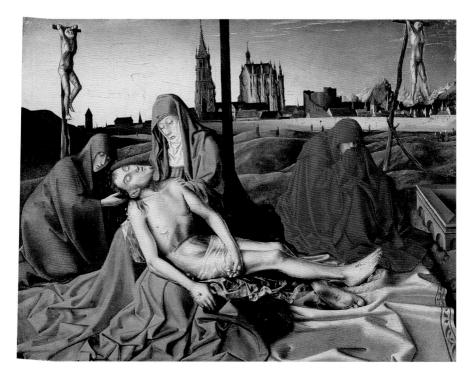

Konrad Witz, Circle of Fifteenth Century

Witz (c.1400–1447) was born in Germany. Though he spent his active years in Switzerland, his influence was widespread and may be traced south of the Alps as well as in the North.

Pietà

Tempera and oil(?) on panel, 13¹/8 x 17¹/2 (33.3 x 44.4) Date unknown Gift of Miss Helen C. Frick. 81.1.172

This *Pietà* evidently was the model for a variant, also in The Frick Collection (see p. 70), by a later artist who added a kneeling donor to the composition. North European characteristics seem stronger in the present, earlier version, which was long attributed to Konrad Witz. This *Pietà* is more dramatically intense, more emotional in the handling of the sharp-featured faces, the angular drapery folds, and the colder tonality of colors and light.

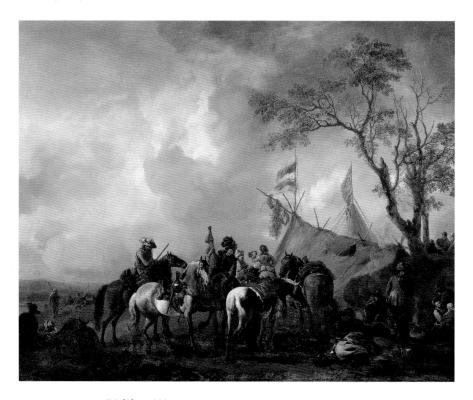

Philips Wouwerman 1619–1668

Wouwerman was born in Haarlem, where he joined the painters' guild in 1640. His style was evidently much influenced by the genre paintings of his fellow townsman Pieter van Laer, called Il Bamboccio. Wouwerman's work was popular in his own time, but the height of his reputation came during the eighteenth and nineteenth centuries.

The Cavalry Camp

Oil on oak panel, 16³/₄ x 20³/₄ (42.5 x 52.7) Date unknown. 01.1.136

Though Wouwerman appears to have spent most of his life in Haarlem, his numerous depictions of army battles suggest that he may have observed Dutch border campaigns or traveled abroad. His subtle sense of color and texture is evident in this composition, which anticipates the tastes of the eighteenth century. Watteau's early military scenes in particular seem to be inspired by precedents such as this.